Rochester
Through Time

MARY HASEK GRENIER
AND EMILY C. MORRY

America Through Time is an imprint of Fonthill Media LLC

Fonthill Media LLC
www.fonthillmedia.com
office@fonthillmedia.com

For all general information, please contact Arcadia Publishing:
Telephone: 843-853-2070
Fax: 843-853-0044
E-mail: sales@arcadiapublishing.com
For customer service and orders:
Toll-Free 1-888-313-2665

www.arcadiapublishing.com

First published 2015, reprinted 2017 and 2019

Copyright © Mary Grenier and Emily Morry 2015, 2017, 2019

ISBN 978-1-63500-022-1

All rights reserved. No part of this publication may be reproduced, stored in a retrieval system or transmitted in any form or by any means, electronic, mechanical, photocopying, recording or otherwise, without prior permission in writing from Fonthill Media LLC

Typeset in Mrs Eaves XL Serif Narrow
Printed and bound in England

Connect with us:
 www.twitter.com/usathroughtime
 www.facebook.com/AmericaThroughTime

America Through Time® is a registered trademark of Fonthill Media LLC

Contents

	Introduction	4
1	Local Landmarks and Institutions	5
2	Historical Moments	23
3	Business and Industry	36
4	Educational Institutions	49
5	Ethnicity, Religion, and Neighborhoods	58
6	Arts and Recreation	71
7	Repurposing Rochester	84
	Bibliography	95
	Acknowledgments	96

Introduction

"Rochester, why Rochester?"
George Bailey, *It's a Wonderful Life* (1946)

Rochester is a waterborne city. The Seneca of the Haudenosaunee, who first inhabited this area, provided the names of our waterways. Ontario is their word for "beautiful waters" and Genesee their name for "beautiful valley." The glaciers that advanced and receded over hundreds of millennia carved a unique landscape.

Watercourses spurred the area's development. The upper and lower falls provided the necessary power for milling flour, grinding corn, and later for driving industries and producing electricity. The Erie Canal, dug out by hand, horse, and shovel by largely immigrant labor rapidly expanded the city's fortunes by providing an inexpensive way to ship products to market.

The Genesee River still retains much of its natural beauty as it flows through the city with trails along the Maplewood area, downtown walkways and many little parks featuring views of the High Falls. Because the river bisects the city, Rochester's many bridges, including the majestic Veteran's Memorial Bridge and the Modern Art-like Freddie-Sue span, are some of its most iconic landmarks.

The city's other defining "watermark" – Lake Effect snow – has also influenced our fortunes by selecting for resilient residents.

To be sure, Rochester has been shaped as much by its inhabitants as by its natural resources. We are a city of foreign immigrants and American migrants, and our industries, by and large, were not developed by children of privilege. The heart of our city is based on ordinary people who do extraordinary things with their lives and resources.

While the fearless activism of the city's most cherished citizens, Frederick Douglass and Susan B. Anthony, helped establish Rochester as a site of social progressivism, the labors of our residents inspired Rochester's reputation at various times as the Flour City, the Flower City, America's First Boomtown and the World Image Center.

The city's leisure industry was initially developed to serve to this hard-working labor base. From beaches to baseball fields, festivals to fine dining, cinemas to concert halls, street art to art galleries, and municipal parks to the public market, Rochester's wide-ranging recreational offerings speak to the diversity of its vibrant population.

Though the city has suffered economic setbacks in the post-industrial era, resourceful Rochesterians have found opportunity in our losses – turning the abandoned factories that had produced the buttons and buggy whips of a bygone era into housing, restaurants, galleries, and new businesses. The city's universities and colleges have served as a constant source of innovation, while many high tech companies with ambitious new ideas have found a home here.

If Rochester's early history was largely defined by the power of its natural resources, the city's inventive residents point toward the promise of its future.

"Why Rochester?"
"Why Not?"

Mary Hasek Grenier and Emily C. Morry

LOCAL LANDMARKS AND INSTITUTIONS

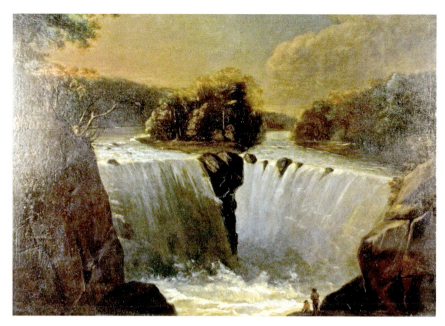

PRIZED PRESIDENTIAL PAINTING: George Washington purchased six landscape paintings during his presidency that reflected the beauty of our new nation. In 1797, when Washington retired to Mount Vernon, he placed these paintings on the wall of the grandest space in the house, the "New Room." One of the two paintings by British immigrant William Winstanley is "Genesee Falls." Although now owned by the Smithsonian Institute, the painting still hangs in its place at Mount Vernon. George Washington, the "Father of our Country" knew of and appreciated our beautiful Genesee Falls when Rochester was still a wilderness. (*Courtesy of Mt Vernon Ladies Association and Smithsonian Institute. Photographer: Gavin Ashworth*)

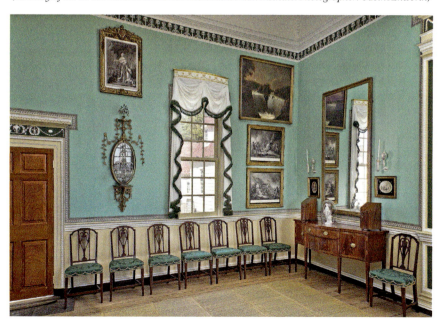

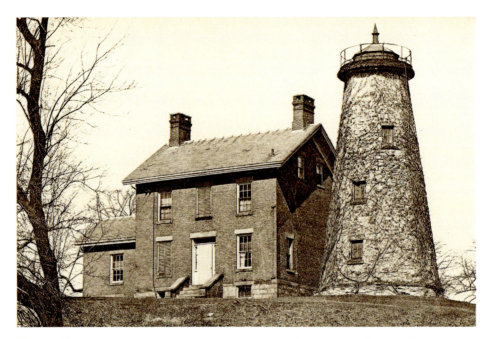

SHINE A LIGHT: The Charlotte-Genesee Lighthouse is the oldest lighthouse still standing on Lake Ontario. The octagonal stone tower was built in 1822 on a bluff overlooking the west shore of the Genesee River. The tower is forty feet tall with a lantern room at the top where the lighthouse keeper kept the lights burning, initially using ten Argand Lamps with reflectors and then later, a lantern with a Fresnel lens. The Keeper and his family resided in the accompanying brick house constructed in 1863. The lighthouse later fell into disrepair, but Charlotte High School students successfully campaigned for its restoration in 1965. (*Top photograph from the Collection of the Rochester Public Library Local History & Genealogy Division. Bottom photograph courtesy of Mike May*)

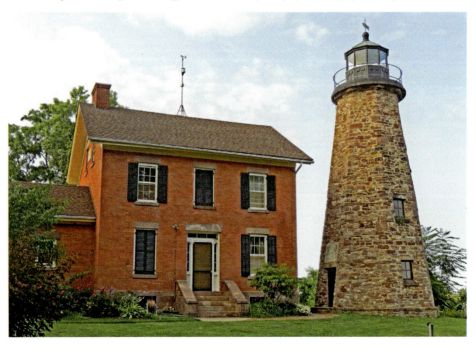

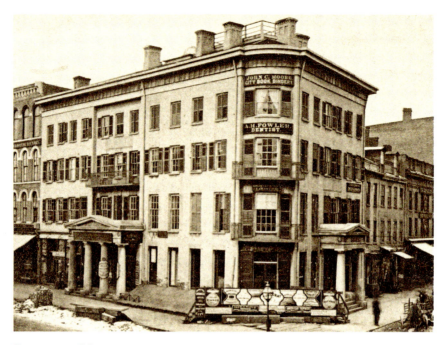

STATE AND MAIN: Rochester's leading hotel for twenty years, the Eagle Hotel, was built on the original site of the pioneer Scrantom family log cabin in 1823. Daniel Powers later constructed his ornate cast iron office building on the corner in 1871. It featured the city's first manually-operated passenger elevator, an art gallery with cases of stuffed birds and an observation tower to view Lake Ontario for ten cents. A rivalry with Samuel Wilder over whose building was taller prompted Powers to add two more stories to his edifice. It remains a *Grand Dame* at the Four Corners. (*Top photograph from the Collection of the Rochester Public Library Local History & Genealogy Division. Bottom photograph courtesy of Mike May*)

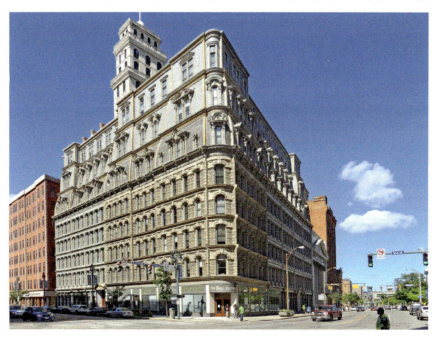

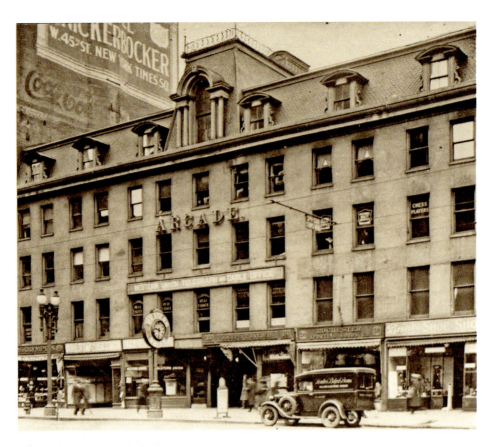

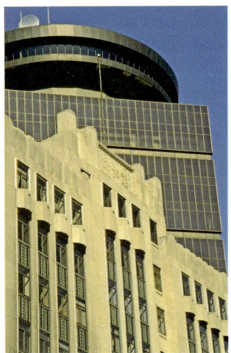

REYNOLDS ARCADE: When early settlers, Abelard and Lydia Reynolds purchased two lots on Rochester's main road, it had only a tavern and a post office. In 1828 Abelard built a four-story brick building with an observation tower, skylight, and eighty-six rooms arranged to be an indoor business mall sheltered from the weather. It was a showcase for the young city and the launching site for both Bausch + Lomb and Western Union. In 1932, the arcade was rebuilt as a stylish Art Deco skyscraper. Its neighbor is First Federal Plaza. The recognizable circular top, once containing a revolving restaurant, houses various offices. (*Top photograph from the Collection of the Rochester Public Library Local History & Genealogy Division. Bottom photograph courtesy of City of Rochester, New York*)

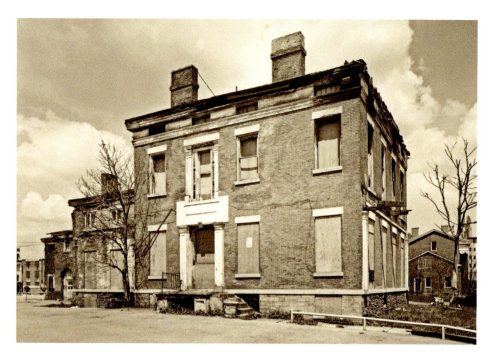

HERITAGE HOUSE: The elegant brick Greek Revival style building at 133 South Fitzhugh Street is known as the Hoyt-Potter House. Built in 1840 by an early Rochester stationary shop owner, David Hoyt, the house was sold in 1850 to Henry Potter, one of the founders of the telegraph company that would become Western Union. The building, located in the historic Third Ward, had fallen into disrepair by the late 20th century. The Landmark Society of Western New York spearheaded a major restoration and the house now serves as their headquarters. This invaluable organization continues to preserve our region's historic architecture. (*Courtesy of Richard Margolis*)

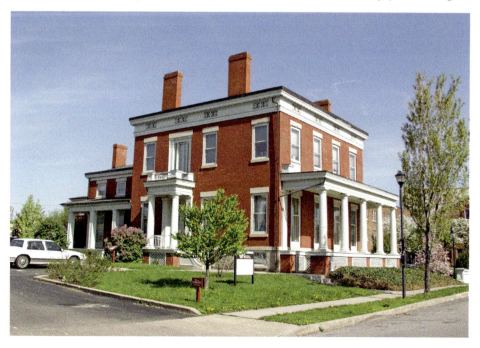

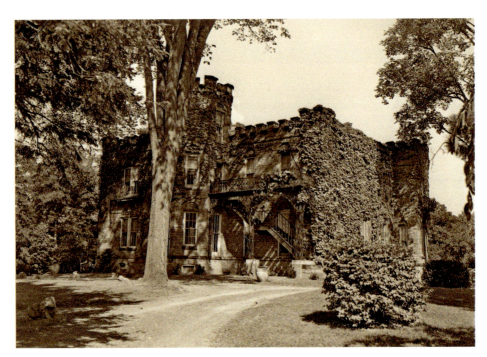

HIGHLAND PARK FORTRESS: Up the drive past the grey, hewn stone gatehouse on Mt. Hope Avenue is one of the most picturesque houses in Rochester, the Warner Castle. Horatio Gates Warner built the structure in 1854 to resemble the Scottish castle of Clan Douglas. A subsequent owner added the ornate sunken garden, designed by famous landscape architect, Alling DeForest. Today the castle is owned by the Monroe County Parks System and is home to the Rochester Civic Garden Center, which offers classes, lectures and a research library for all aspects of gardening and botany. (*Top photograph courtesy of City of Rochester, New York*)

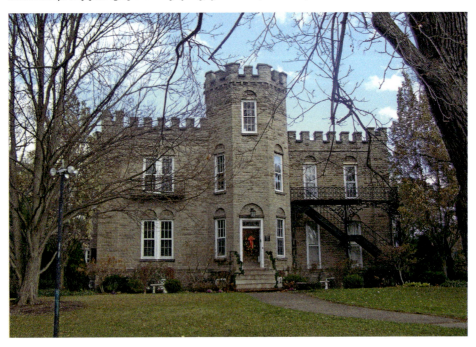

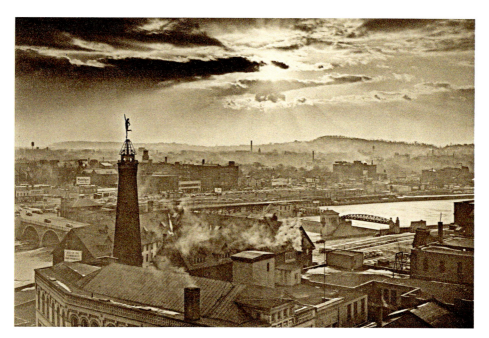

A STATUE RESURFACED: William S. Kimball's Peerless Tobacco Co, was a well-known local cigarette manufacturer. In 1881 the company added a twenty-one foot tall copper statue of Mercury, Roman messenger of the gods, to the smokestack of its Tudor-style factory on Court Street. Appropriately for Rochester, the J. Guerney Mitchell-designed statue stood upon the 'God of the North Wind'. When the Kimball factory was demolished to make way for the Community War Memorial, the statue was placed into storage until the Lawyer's Cooperative Publishing Company built a tower on the Aqueduct Building so Mercury could join the "Wings of Progress" in the city skyline. (*Top photograph courtesy of Department of Geology, University of Rochester. Bottom photograph courtesy of City of Rochester, New York*)

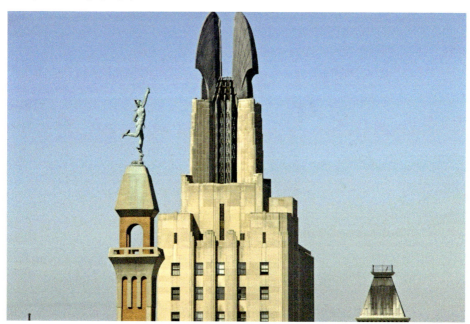

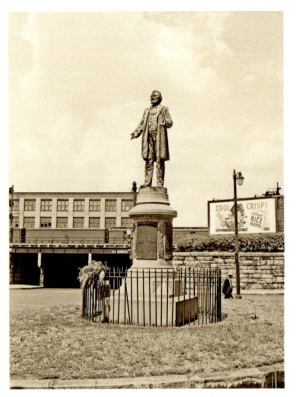

MOVING MONUMENT: The first statue in the country to commemorate an African American citizen, this Frederick Douglass sculpture was the result of a campaign to include a Black presence in the Soldiers and Sailors Monument. Following the abolitionist's death in 1895, city leaders decided to make Douglass the sole honoree instead. Ten thousand witnesses attended the monument's 1899 unveiling on the corner of Central Avenue and St. Paul Street, including then governor, Theodore Roosevelt. Due to congestion in the area, officials decided to relocate the statue to Highland Park in 1941, a mere 300 yards away from Douglass' former South Avenue home. (*Top photograph courtesy of City of Rochester, New York*)

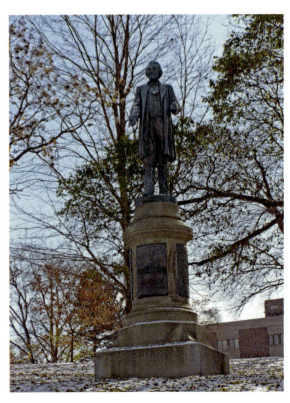

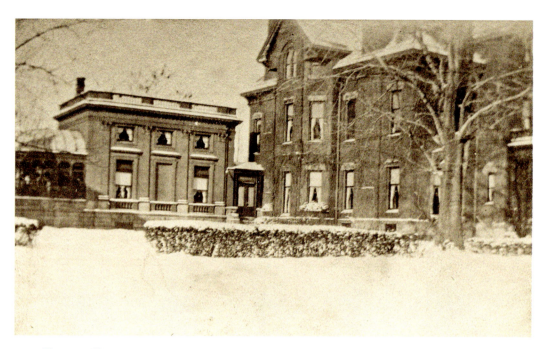

FRENCH TWIST: A joint effort by architects John Du Fais and Harvey Ellis, the Watson Library once adjoined the Prince Street home of prominent Rochesterians James and Emily Sibley Watson. The 1903 addition was a near replica of Marie Antoinette's summer palace, Le Petit Trianon. The daughter of Hiram Sibley, Emily Sibley Watson founded the Memorial Art Gallery. Her son James Sibley Watson, Jr. was a doctor and well known as a director of avant-garde films. The family mansion was torn down in the 1950s, but the library wing remains as a private home and a local treasure. (*Top photograph from the Collection of the Rochester Public Library Local History & Genealogy Division. Bottom photograph courtesy of the Landmark Society of Western New York*)

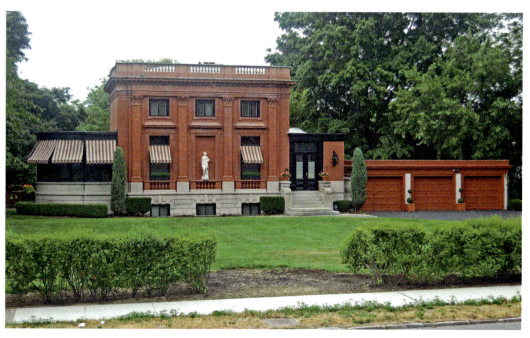

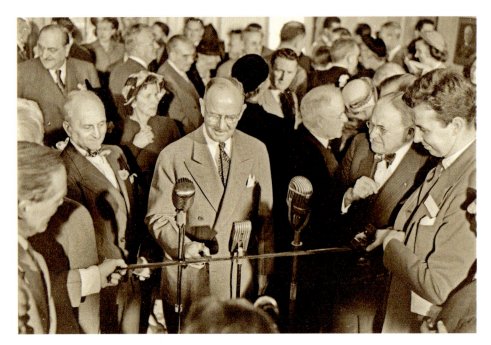

GEORGE EASTMAN HOUSE: Home to one of Rochester's best known entrepreneurs, this Georgian Revival residence on East Avenue included forty-nine rooms when it was built in 1905. The film innovator and philanthropist willed his residence to the University of Rochester upon his death in 1932. It served as the university president's house until it was converted into a photography and film museum. Since Kodak president T. J. Hargrave ceremonially opened the institution in 1949, it has grown to include the Dryden Theatre and an extensive archive which now preserves the personal film collections of notable directors like Martin Scorsese and Spike Lee. (*Top photograph courtesy of the George Eastman House*)

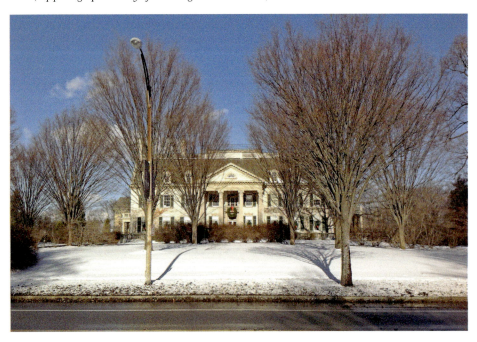

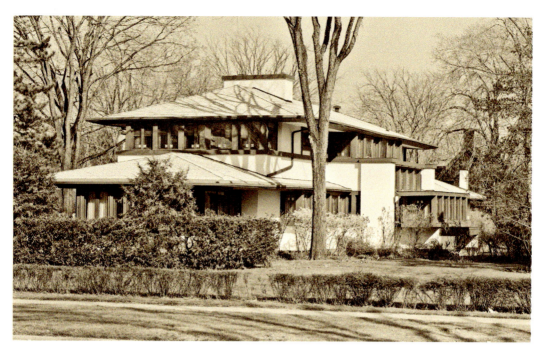

A PRAIRIE HOME: The Boynton House at 16 East Boulevard is Rochester's only Frank Lloyd Wright-designed building. It was built in 1908 for Edward Boynton. Wright himself supervised the construction. The house is both a local and national treasure. It is one of Wright's Prairie Style designs with a shallow, sloping roof, overhangs, strong horizontal lines and an open floor plan interior built in harmony with the environment. The current owners have rehabilitated the house to its original beauty, conserving the home's Wright-designed furniture and restoring its 253 iconic art glass panels and windows. (*Top photograph courtesy of the Library of Congress*)

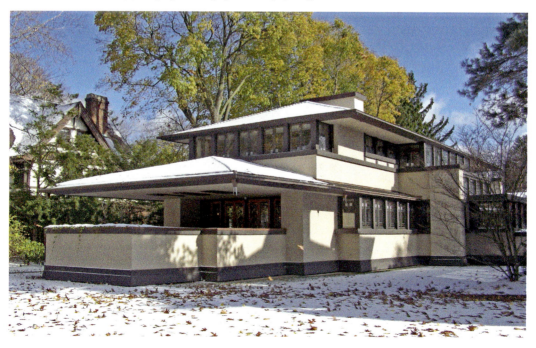

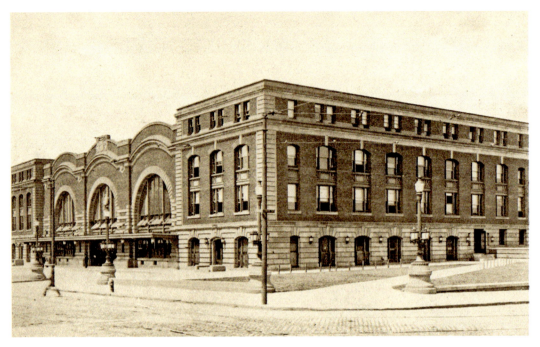

SPECTACULAR STATION: Considered to be local architect Claude Bragdon's masterpiece, Rochester's third New York Central Railroad Station opened in 1914. Featuring a design emulating the wheels of a train, the spacious Central Avenue depot wowed locals and visitors alike. Unfortunately, as train travel declined over the course of the 20th century, the New York Central Railroad could no longer afford to maintain the luxurious stations lining its routes. Along with many other depots across the state, the Bragdon station was torn down in the 1960s and replaced with a more functional and less aesthetically pleasing structure. (*Top photograph from the Collection of the Rochester Public Library Local History & Genealogy Division*)

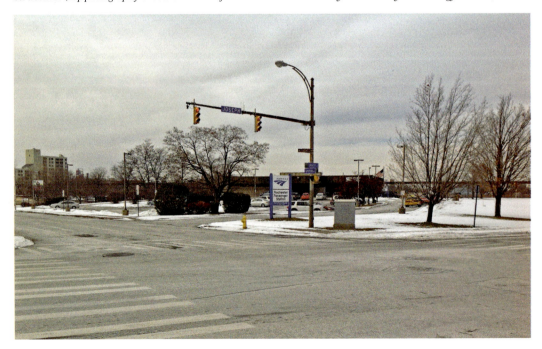

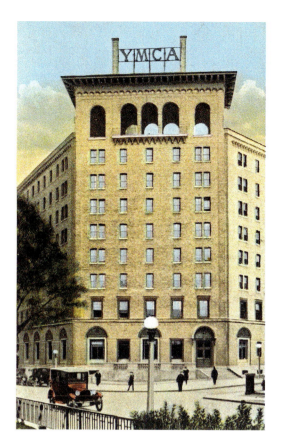 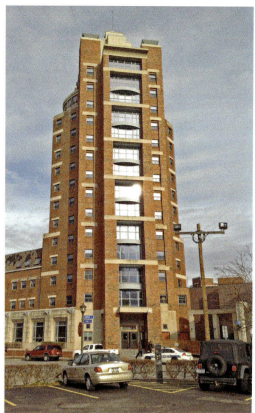

CORNER OF GIBBS AND GROVE: At eight stories tall, the Gibbs Street YMCA was one of Rochester's early skyscrapers. Deemed "the most up-to-date YMCA building in any city of its size" when it opened in 1916, the Italian Renaissance-style club headquarters provided residents with athletic amenities, game rooms, a cafeteria, an assembly hall and a rooftop garden for men whose jobs kept them indoors. The building was designed to provide the city's newcomers with a wholesome transitional residence, but over the years faced growing competition from motels and traditional apartments. The Eastman School of Music's living center replaced the aging structure in 1991. (*Left photograph from the Collection of the Rochester Public Library Local History & Genealogy Division*)

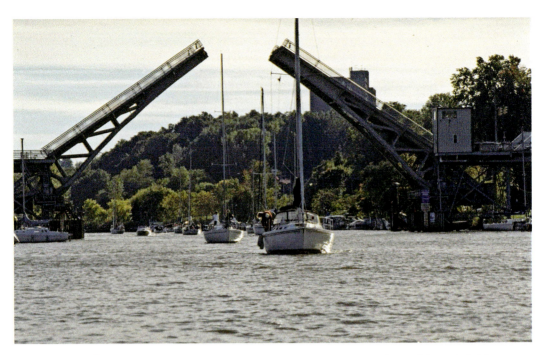

CONNECTING COMMUNITIES: Stutson Street, which led up to this cantilevered, bascule bridge, gave the span its name. Constructed in 1916, the bridge was built over the Genesee River to connect the towns of Greece and Irondequoit with Rochester's newly annexed neighborhood, Charlotte. In 2004 a new span opened, classically designed and destined to be a local landmark. It is named in honor of Colonel Patrick Henry O'Rorke, Rochester's most recognized Civil War hero. O'Rorke commanded the "Rochester Raiders" of the 140th NY Volunteer Infantry and was killed leading his men at Little Round Top during the battle of Gettysburg in 1863. (*Top photograph courtesy of City of Rochester, New York*)

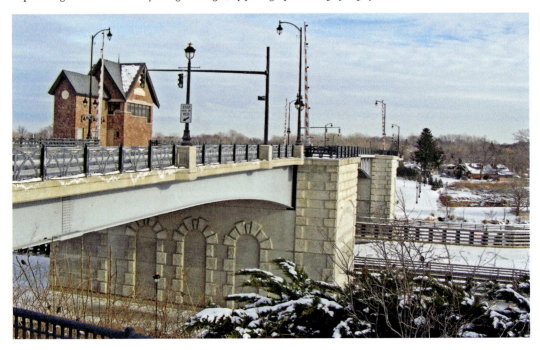

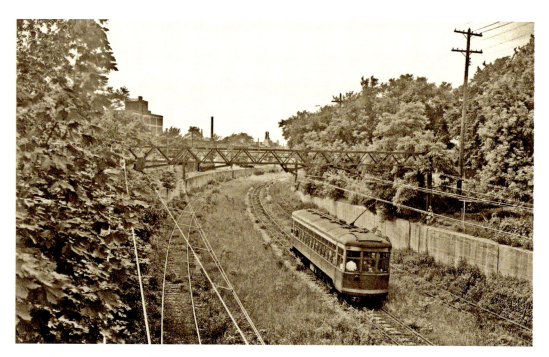

TRANSPORTATION TRANSFORMATION: Making use of the abandoned Erie Canal bed following the waterway's relocation, the Rochester Industrial & Rapid Transit Railway opened in 1927. Subway patronage peaked during WWII and the immediate post-war years due to gas and tire rationing as well as a federally-ordered bus service reduction. By 1948, however, most Rochesterians had reverted back to car use. Low ridership combined with the city's need for an eastern connection to the Thruway from the Inner Loop, led to the transportation system's removal in 1956. The cars of individual commuters now coast along the route that communal subway cars once traveled. (*Top photograph courtesy of City of Rochester, New York*)

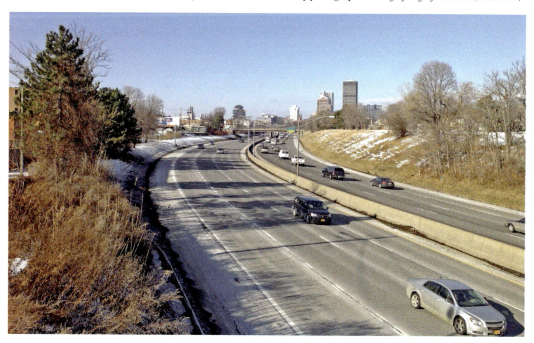

ARTISTIC SPAN: The Troup-Howell, a low multi-girder bridge, connected Troup Street and Howell Street as I-490 was carried over the Genesee River in 1954. The Frederick Douglass-Susan B. Anthony Memorial Bridge replaced the aging structure in 2007. Affectionately nicknamed the "Freddie-Sue," the triple steel arch design bridge resembles a bright white Modern Art sculpture hovering over the river. The Freddie-Sue is now a very recognizable signature in Rochester's skyline. Even the underside of the bridge is artistically designed for the pleasure of pedestrians who walk the pathways along the Genesee River's bank. (*Top photograph courtesy of City of Rochester, New York. Bottom photograph courtesy of Xerox Corporation*)

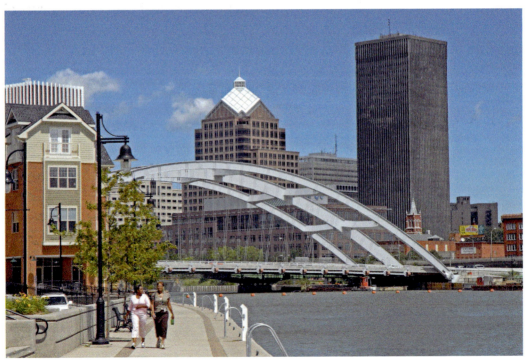

COMMUNITY WAR MEMORIAL: Following WWII, the City of Rochester planned a memorial civic center in honor of the Americans who had fought and died in foreign wars. A public drive raised 1.5 million dollars. The resulting building, dedicated Memorial Day 1956, attracted Rochesterians to sporting events, public ice skating, circuses and concerts by legendary bands such as the Grateful Dead. By 1998, a renovated Blue Cross Arena at the War Memorial reopened. The glass lobby with dynamic graphics enlivens the corner of Broad and Exchange. The Arena is currently the home base of the Rochester Americans, the Razorsharks, the Lancers and the Knighthawks. (*Top photograph courtesy of City of Rochester, New York. Bottom photograph courtesy of Blue Cross Arena*)

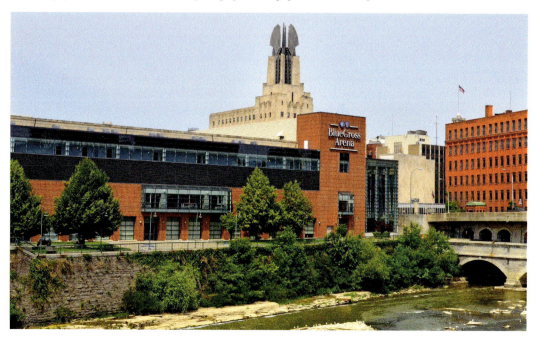

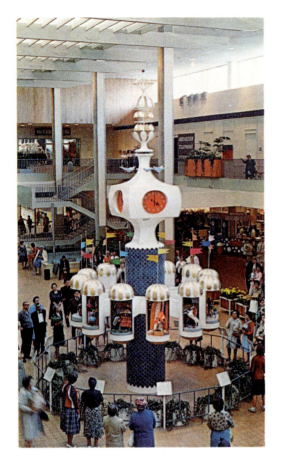 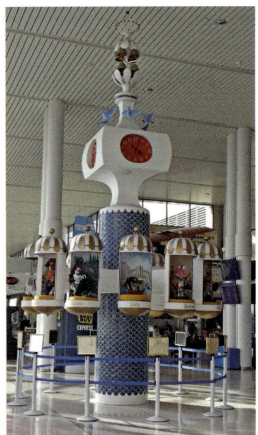

TIME TRAVELS: The Clock of Nations was the colorful centerpiece of Midtown Plaza, the first urban shopping mall in the country, built in 1962. Twelve scenes of marionettes danced to their countries' music, while the tower spun around and bluebirds of happiness flew overhead. When Midtown Plaza closed in 2008, the clock traveled three miles southwest of downtown to the main concourse of the Greater Rochester International Airport. The airport's predecessor, Britton Field, launched its first flight in 1919 and drew large crowds for events like the "Flying Circuses" and Charles Lindbergh's visit on the *Spirit of St. Louis* in 1927. (*Left photograph from the Collection of the Rochester Public Library Local History & Genealogy Division. Right photograph courtesy of the Greater Rochester International Airport*)

HISTORICAL MOMENTS

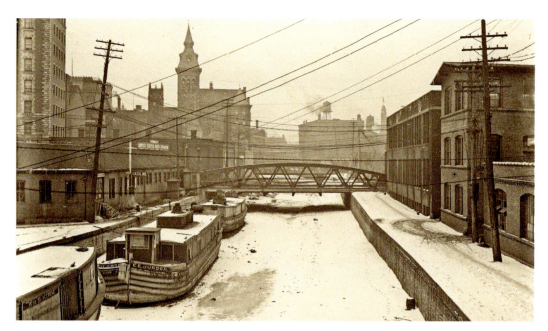

DOWNTOWN THOROUGHFARE: The Erie Canal, which opened locally in 1825, was instrumental in establishing Rochester as one of America's first boomtowns. By providing a direct link to the Great Lakes and the cities along them, the canal supplied Rochester's exporters with an inexpensive, rapid transport route and gave them an advantage over manufacturers further east. By the early 20th century, the waterway had become too narrow and shallow for commercial service so city planners devised a new route. Broad Street replaced the canal in 1924, providing a much needed additional East-West roadway and a roof for part of the city's subway system. (*Top photograph from the Albert R. Stone Negative Collection, Rochester Museum & Science Center Rochester, N.Y.*)

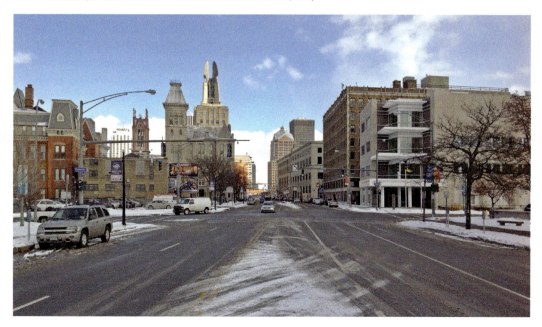

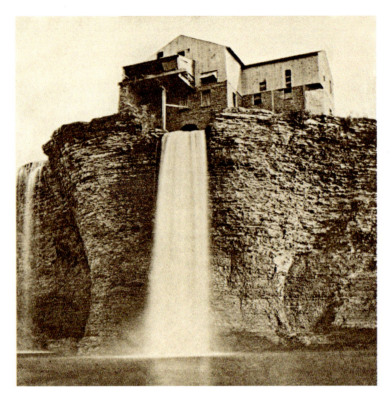

FATEFUL FALLS: Legend has it that daredevil Sam Patch began jumping waterfalls to earn money after his business partner ran away with their New Jersey mill profits. Having completed a jump off of Niagara Falls unscathed, Patch set his sights on Rochester's Upper Falls. After a successful jump from the site of Thomas Parsons' High Falls saw mill, Patch scheduled a second leap for Friday, November 13, 1829. Tragically, he did not resurface. His frozen body wasn't recovered until St. Patrick's Day, 1830. The Gorsline Building now marks the spot where Sam Patch leapt to his early grave. (*Top photograph from the Collection of the Rochester Public Library Local History & Genealogy Division*)

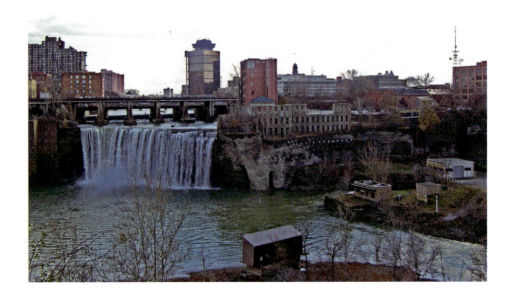

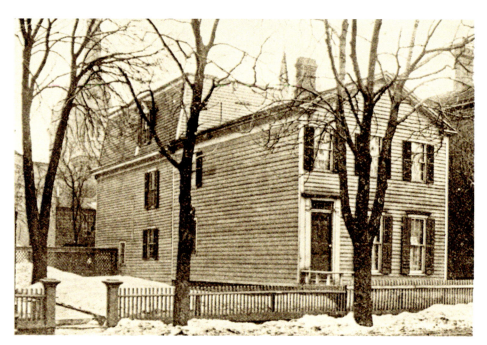

CORNER OF CHURCH STREET AND NORTH PLYMOUTH AVE: This downtown intersection has housed three significant local landmarks. Quaker abolitionists Amy and Isaac Post moved here in the 1840s and offered up their home as a stop on the Underground Railroad. The residence likely sheltered more escaped slaves on their way to Canada than any other location in Rochester. The Central Presbyterian Church later built on this site hosted the funerals of both Frederick Douglass and Susan B. Anthony. When the church merged with two other Presbyterian institutions in the mid-1970s, the renowned Hochstein School of Music and Dance moved in and later renovated the entire facility. (*Top photograph from the Collection of the Rochester Public Library Local History & Genealogy Division*)

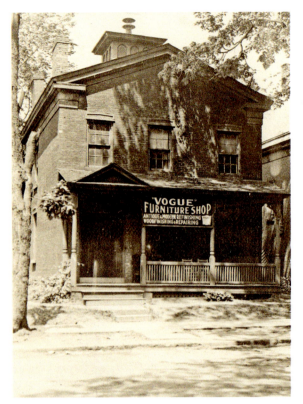

VANISHING HISTORY: An escaped slave from Maryland, Frederick Douglass became a leader of the abolitionist movement. He lived in this Alexander Street house south of East Avenue from 1847 to 1852. Douglass both resided and worked here, penning articles for his newspaper, *The North Star*, writing speeches, and organizing Underground Railroad activities. The Douglass family residence also doubled as a rest stop for escaped slaves en route to Canada. Later repurposed as a storefront, the former Underground Railroad station was unfortunately torn down in 1954, leaving a parking lot in the wake of the historic site. (*Top photograph from the Collection of the Rochester Public Library Local History & Genealogy Division*)

PUBLISHING LANDMARK: Named after John T. Talman, the son-in-law of city co-founder William Fitzhugh, this early 19th century office building on the corner of Main and Aqueduct has housed a myriad of tenants in its long history, but perhaps none more significant than abolitionist, Frederick Douglass. Douglass not only published his anti-slavery *North Star* newspaper within these walls from 1847 to 1863, but he also used his one-room office as a temporary shelter for escaped slaves. Since its days as an Underground Railroad stop, the much-altered Talman Building has headquartered the *Rochester Evening Express* and a variety of professional offices. (*Top photograph from the Albert R. Stone Negative Collection, Rochester Museum & Science Center Rochester, N.Y.*)

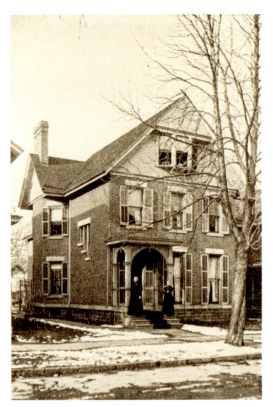

17 Madison Street: Home to Susan B. Anthony and her sister Mary, this Victorian house functioned as the national women's rights headquarters in the 19th century. Here, Anthony composed resolutions and met with fellow suffragists and civil rights leaders. The building's significance was nevertheless forgotten following the Anthony sisters' deaths in the early 1900s. A campaign launched by the Rochester Federation of Women's Clubs in 1945 spearheaded the house's restoration. Designated the first National Historic Landmark in Rochester in 1965, the largely volunteer-run museum has received countless visitors over the years, including a recent appearance by long rider Bernice Ende and mounted police. (*Top photograph courtesy of National Susan B. Anthony Museum and House, Rochester, NY. Bottom photograph courtesy of Gloria Weyerts*)

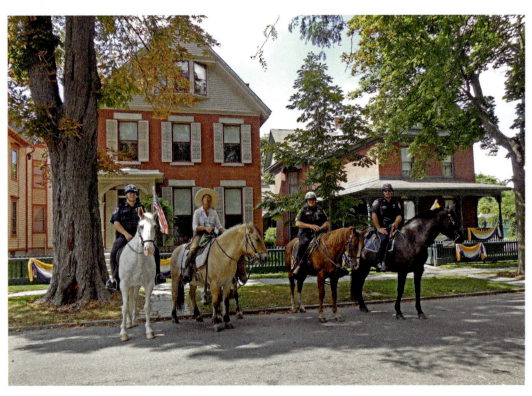

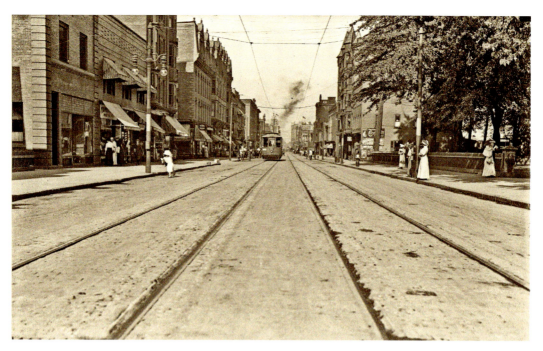

SIGNIFICANT SUFFRAGIST SITE: History happened on this section of West Avenue (now Main Street), east of Litchfield Street in 1872. On November 8, Susan B. Anthony and her sisters Guelma, Hannah, and Mary walked from the Anthony home on Madison Street to a polling place located at the current site of Café 1872. They, along with nine other women, voted at the locale and the illegal action prompted Anthony's arrest and trial. Continued brave acts and lobbying by suffragists eventually resulted in the passage of the 19th Amendment in 1920. Café 1872, part of the Voter's Block Community development, commemorates the location's significance. (*Top photograph courtesy of City of Rochester, New York*)

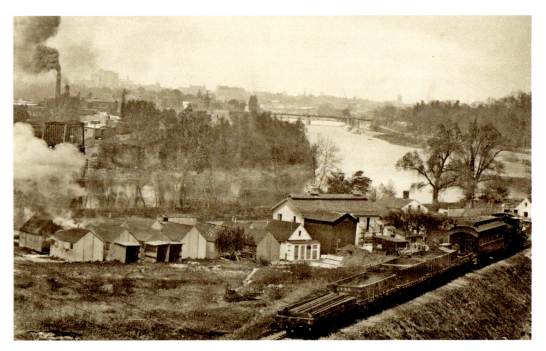

MAKESHIFT MEDICAL CENTER: Hope Hospital, founded in 1869, was built on the Genesee river flats to the back of the Mt. Hope Cemetery on what is now Wilson Boulevard. Known as a "Pest House," the institution kept patients with contagious disease in isolation. During the city's smallpox epidemic of 1902, the unpainted wooden building could only accommodate twenty of the over 1,000 cases of smallpox. The other victims were housed in canvas tents set up along the river's edge. Today, the site includes the meandering trail along the riverbank and one of the University of Rochester's parking lots. (*Top photograph from the Collection of the Rochester Public Library Local History & Genealogy Division*)

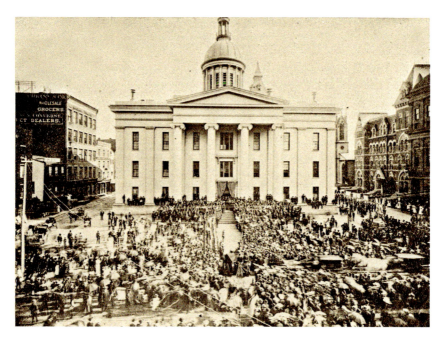

MOURNING ON MAIN STREET: The second Monroe County Courthouse was built in the classical style, inspired by the architecture of Washington, DC. In 1884 residents gathered here for the funeral of Rochester's Lt. Frederick Kislingbury, who died on the ill-fated Greely Arctic Expedition. Shipwrecked, the crew made it to shore with few provisions. Only seven survived. Rumors of cannibalism were unfortunately found to be true following Kislingbury's exhumation. J. Foster Warner designed the current Italian Renaissance-style Monroe County Office building at 39 West Main Street. The interior is one of the city's most celebrated, with marble columns, graceful arches and ornate plaster lions. (*Top photograph from the Collection of the Rochester Public Library Local History & Genealogy Division*)

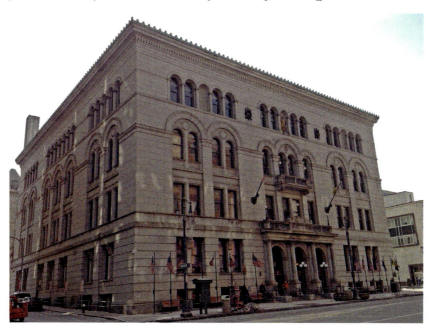

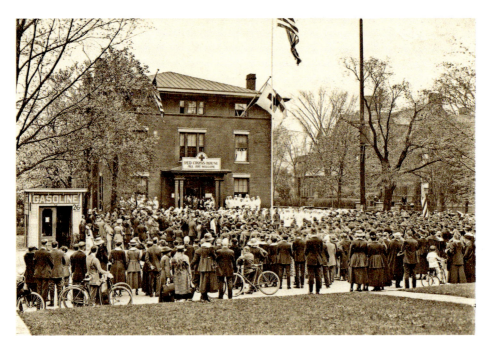

CORNER OF EAST AND ALEXANDER: Built as the Rochester Friendly Home on the former site of the Old Alexander Tavern, this edifice housed the Red Cross during World War I. The second chapter of the national organization, Rochester's Red Cross played an invaluable role during the war years, offering aid to soldiers abroad and help at home amidst the Influenza Epidemic of 1918. After the armistice, the chapter relocated and Hiram W. Sibley erected an office building in place of the former humanitarian headquarters. Fittingly, in 2015 an Irish pub named Murphy's Law graces the corner where the Old Alexander Tavern originally stood over a century ago. (*Top photograph from the Collection of the Rochester Public Library Local History & Genealogy Division*)

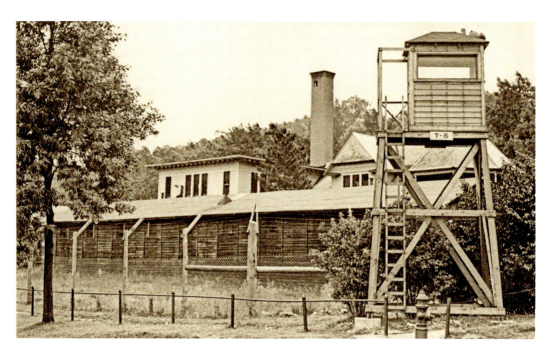

PARK'S DARK PAST: Now a pastoral space for recreation and relaxation, Cobbs Hill Park was the site of a POW camp during WWII. In September 1943, sixty Italian prisoners of war were brought to the Culver Street camp, only to be released shortly after Italy declared war on Germany a month later. One hundred Germans took their place the following summer. Supplementing the labor shortage the war had wrought, captives worked ten-hour days harvesting and canning a variety of crops. Tensions between German POWs and American soldiers resulted in the prisoners' relocation, but the Cobbs Hill camp remained in place until the Armistice. (*Top photograph from the Collection of the Rochester Public Library Local History & Genealogy Division*)

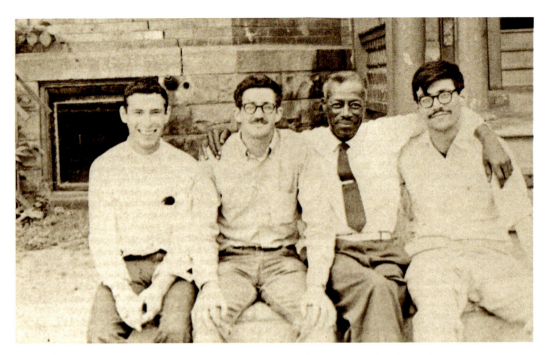

HOUSE'S HOME: Most Rochesterians did not realize they had a blues legend in their midst until young music enthusiasts, Nick Perls, Dick Waterman, and Phil Spiro, "rediscovered" Son House at his Greig Street home in 1964. Initially a preacher, House was a noted Mississippi Delta bluesman in the 1930s. Retiring from the scene in the 1940s, he relocated to Rochester to work for the New York Central. The young men who tracked House down after becoming enamored with his recordings, helped re-launch his career. Though 61 Greig Street was torn down, a nearby plaque commemorates the erstwhile residence of the internationally-acclaimed musician. (*Top photograph courtesy of Dick Waterman*)

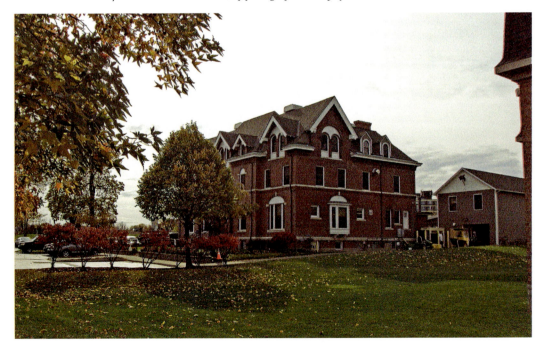

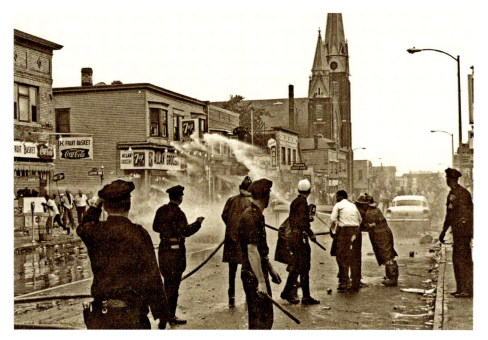

MELEE ON JOSEPH AVENUE: Rochester was among eight American cities to experience a racial uprising in the summer of 1964. Most of these uprisings, including Rochester's, were sparked by an altercation with police that marked the tipping point of years of frustration over inequalities in housing, employment, education and law enforcement. The three-day riot of July 1964 began at a Joseph Avenue street dance and spread throughout the 7th Ward and Southwest Quadrant before being quelled by the National Guard. 250 businesses were destroyed and five citizens died in the process. Today, housing units occupy many areas where riot-era shops once stood. (*Top photograph courtesy of City of Rochester, New York*)

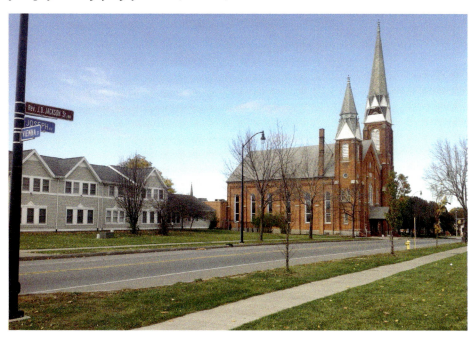

Business and Industry

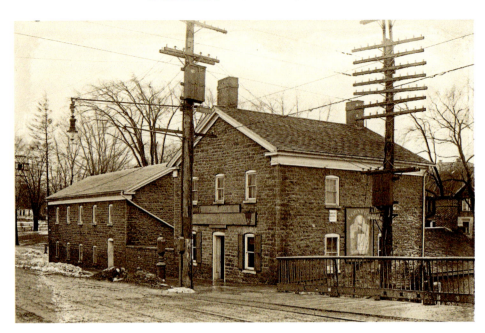

Riverside Rectifier: Before it became part of the University of Rochester, much of the land comprising the River Campus belonged to entrepreneur Epaphras Wolcott, who established a distillery below the Clarissa Street (now Ford Street) Bridge in 1827. Distilleries were some of the earliest businesses in the Rochester area and helped stimulate local corn and rye production. Though many liquor manufacturers suffered setbacks with the rise of the Temperance movement in the mid-19th century, Wolcott's multi-generational family business, best known for its "Corn Hill Rye," survived until the construction of the Barge Canal required the demolition of its headquarters in 1918. (*Top photograph from the Albert R. Stone Negative Collection, Rochester Museum & Science Center Rochester, N.Y.*)

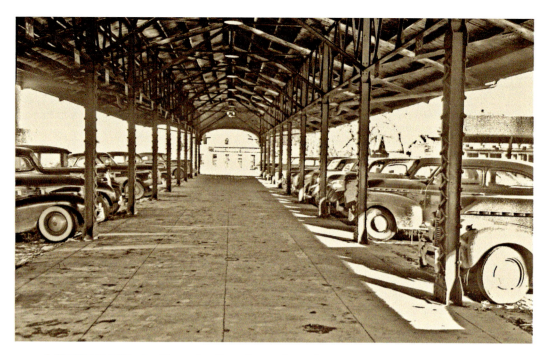

A MOVEABLE FEAST: Situated on Front Street when it first opened in 1827, Rochester's Public Market relocated several times before taking root at its current North Union Street address in 1905. Chosen for its central location and proximity to the railroads, the new market drew thousands of visitors weekly. The marketplace grew increasingly congested as cars and trucks replaced the horses and wagons of years past, so the city expanded the site in 1951. Though supermarkets have presented competition in recent years, the Public Market remains both a haven for fresh, regional produce and a unique community gathering space. (*Courtesy of City of Rochester, New York*)

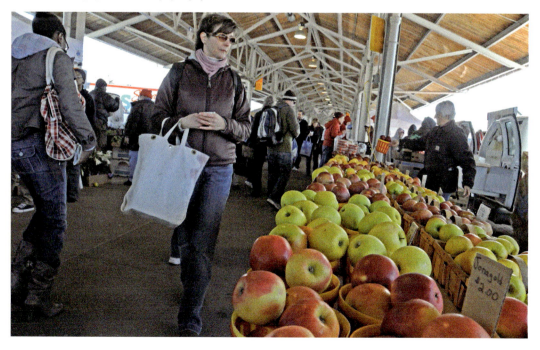

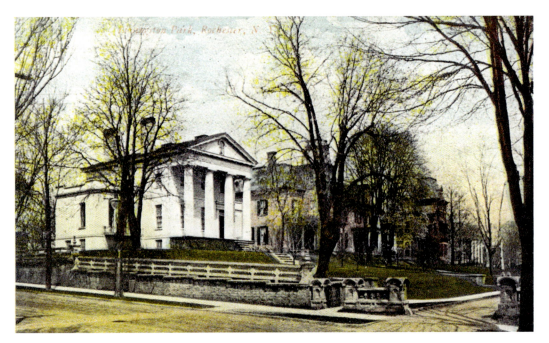

MILLER'S MANSION: Located on Livingston Park, the most elite street in Rochester's historic Third Ward neighborhood, this Greek Revival mansion was built in 1837 for early settler, Hervey Ely. Ely's two flour mills on the Genesee River were among the largest in America, and along with Elisha Johnson and Francis Brown's operations, helped Rochester earn its reputation as "the Flour City." A grain market crash nevertheless forced Ely to sell his luxurious residence in 1841. Artist Ralph Avery later occupied an apartment on the second floor. Since 1920 the estate has served as the headquarters of the Irondequoit chapter of the DAR (Daughters of the American Revolution). (*Top photograph from the Collection of the Rochester Public Library Local History & Genealogy Division*)

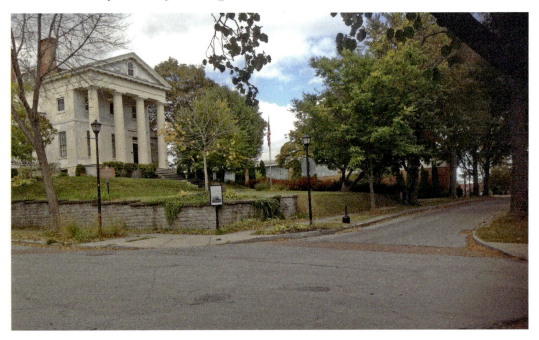

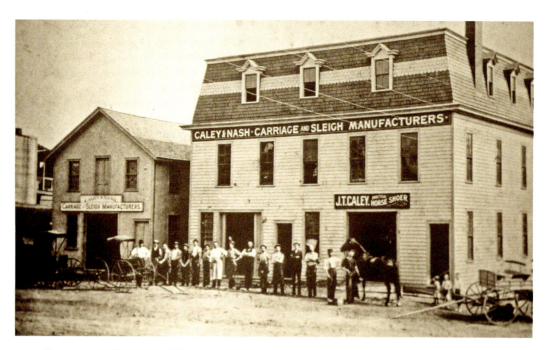

CORNER OF EAST AND WINTON: Before it was annexed by the City of Rochester, this intersection formed the center of Brighton village. Locals referred to the area as "Caley's Corners," after the establishment that marked the site for over a century. Thomas Caley opened his blacksmith shop here in 1842, but quickly shifted gears to carriage manufacturing. The company, which later became known as "Caley and Nash," produced the largest horse-drawn carriages in the country before making the transition to auto-repair. Caley's former corner now houses Wegmans, the successful Rochester-based company which consistently ranks as one of the best reputed corporations in the country. (*Top photograph courtesy of Town of Brighton. Bottom photograph courtesy of Wegmans*)

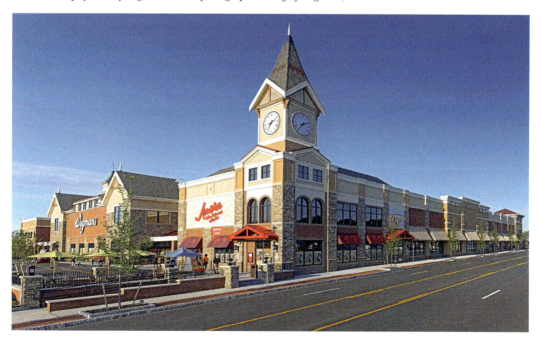

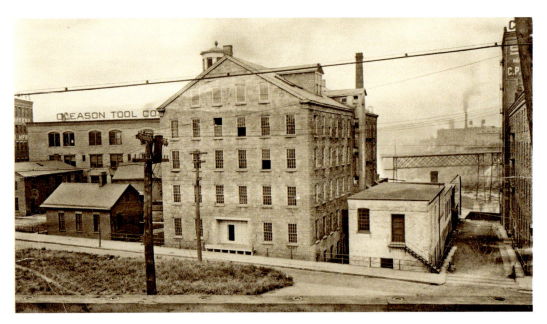

TOOL TIME: Irish immigrant William Gleason moved to Rochester to escape the potato famine. In 1865 he started a machine tooling factory in Brown's Race, the city's industrial center, to take advantage of the High Falls' power. The family company prospered and daughter, Kate Gleason, broke barriers as a female engineer, entrepreneur and visionary. The RIT School of Engineering is named in her honor. In 1905 Gleason Corporation built a classically designed headquarters at the former site of the Culver Baseball Stadium on University Avenue. Gleason Corporation remains a world leader in machine tooling production, especially gears for the automotive industry. (*Top photograph from the Collection of the Rochester Public Library Local History & Genealogy Division. Bottom photograph courtesy of City of Rochester, New York*)

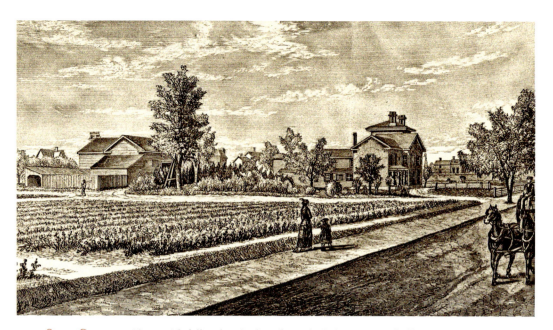

SEED CENTER: Along with fellow horticulturalists, C. F. Crosman and Ellwanger and Barry, James Vick helped inspire a shift in Rochester's identity from "the Flour City" to "the Flower City." In 1866, Vick established a nursery on East Avenue that stretched from Bowen Street (now Barrington) to Vick Park A. The plot became one of the most famous gardens in the world and by the 1870s Rochester was acknowledged as the top seed center in the country. Part of Vick's property was later used as a race track before the land was developed for the impressive homes that mark the area today. (*Top photograph from the Collection of the Rochester Public Library Local History & Genealogy Division*)

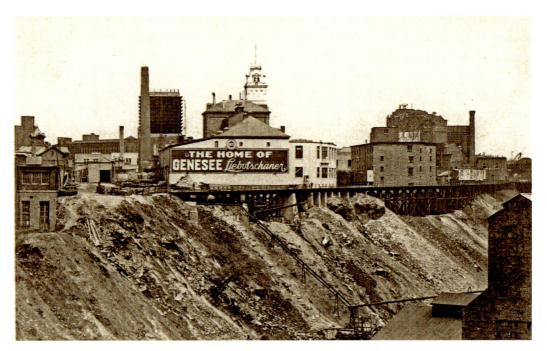

HOPS HAVEN: Though the first ale was brewed in Rochester in 1819, it wasn't until German immigrants arrived to the area *en masse* in the 1830s and 1840s that the local beer industry took off. Initially called the Aqueduct Spring Brewery, the Genesee Brewery (known by that name since 1878) is the only one of Rochester's original beer manufacturers to have survived Prohibition. Located on St. Paul Street, the brewing company best known in the post-repeal era for its Liebotschaner and Twelve Horse Ales, recently converted a building on its campus into the Genesee Brew House, a popular riverside restaurant and museum. (*Top photograph courtesy of the Genesee Brewing Company*)

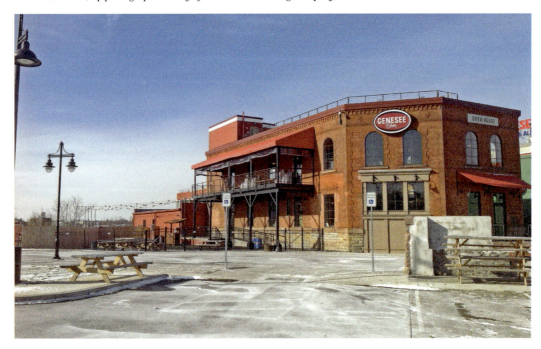

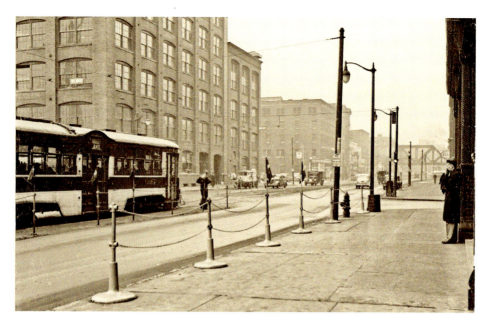

300 State Street: Founded in 1887, the Rochester Button Factory was once the largest button manufacturer in the country. The city's thriving garment industry, which included companies like Hickey Freeman, Arrow, and Fashion Park provided a local market. At the height of its productivity, the company employed 500 workers and produced an estimated 3.6 billion buttons a year in thousands of designs and sizes. Rochester's buttons, which had a reputation for quality, were first made from a nut called vegetable ivory and then from plastic. Button production ceased by 1990. The building now houses lofts and offices, including that of communications company, Shoretel. (*Top photograph courtesy of City of Rochester, New York*)

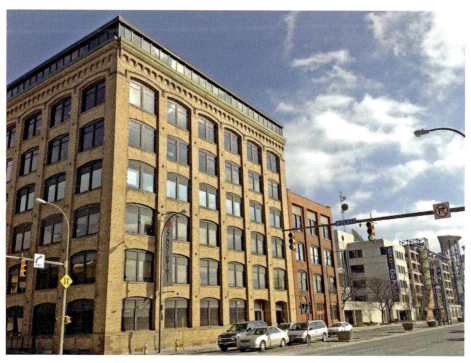

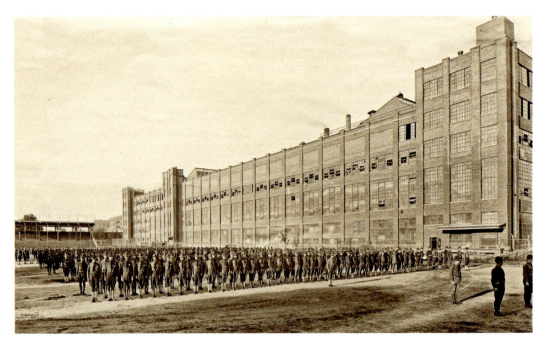

PASTORAL PRODUCTION CENTER: As his photographic business expanded at the turn of the century, George Eastman sought an open park setting for his factories. Built on land north of Ridge Road at the King's Landing pioneer site, Kodak Park soon had acres of factories boasting the tallest smoke stacks in America. The plot also included its own railroad, fire department, medical center, theater, and athletic fields. This photo shows servicemen who attended the School of Aerial Photography during WWI. The front portion of the edifice on Lake Avenue has been demolished. The remaining building is closer to the monument above George Eastman's ashes. (*Top photograph from the Collection of the Rochester Public Library Local History & Genealogy Division*)

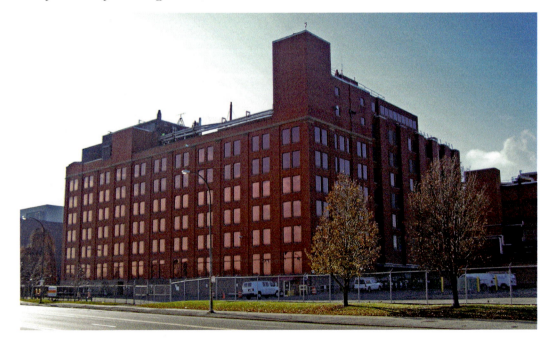

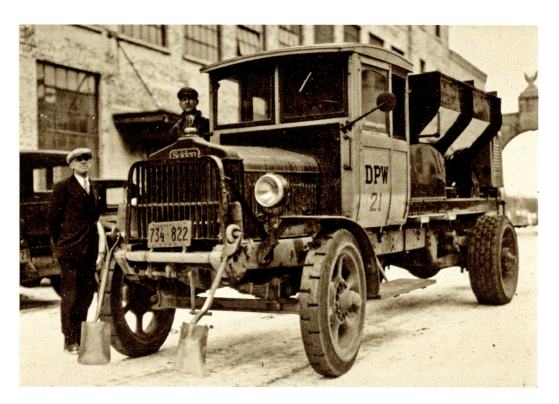

FROM CARS TO COMMUNICATIONS: In 1879 George B. Selden, a local patent attorney and inventor, applied for the first patent for an internal combustion engine horseless carriage. His Probert Street company produced Selden Automobiles and later trucks. WWI brought many orders for Selden's Model B Liberty Trucks. Harris Corporation occupies the site today. It was founded by three engineers and a lawyer in a Park Avenue basement in 1960 with the goal to provide superior long range, two-way radio communications. Now a $2 billion business, the company has received many accolades for excellence and employs a large, skilled local workforce. (*Top photograph courtesy of City of Rochester, New York. Bottom photograph courtesy of Harris Communications*)

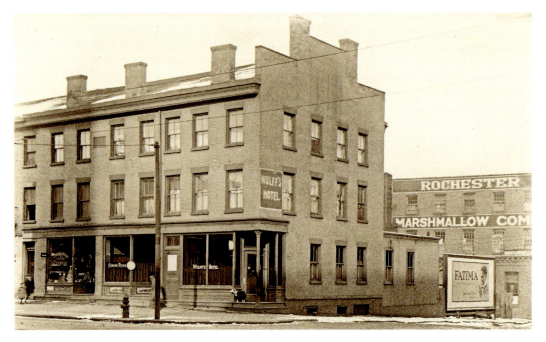

SWEET EMPORIUM: Though Rochester cannot take credit for *inventing* the marshmallow, local citizen Joseph Demerath created the first machine to cast the candy, making him the first confectioner to produce marshmallows on a commercial scale. The Rochester Marshmallow Company, founded in 1895, relocated to the corner of Factory and Mill Streets after a fire destroyed its Mortimer Street headquarters. It produced a wide variety of chocolates and penny candies, but was best known for its prize-medal marshmallows. The former sweets factory has housed Rochester Plumbing Supply since the 1930s, but the faded sign of the Rochester Marshmallow Company is still visible today. (*Top photograph from the Albert R. Stone Negative Collection, Rochester Museum & Science Center Rochester, N.Y.*)

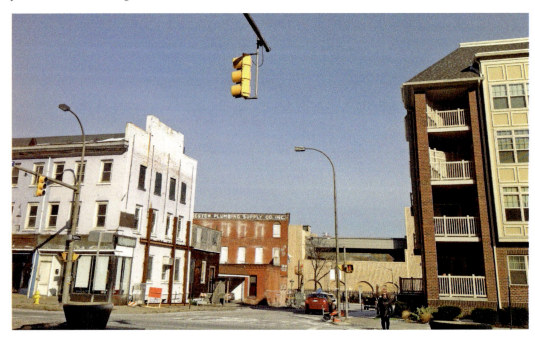

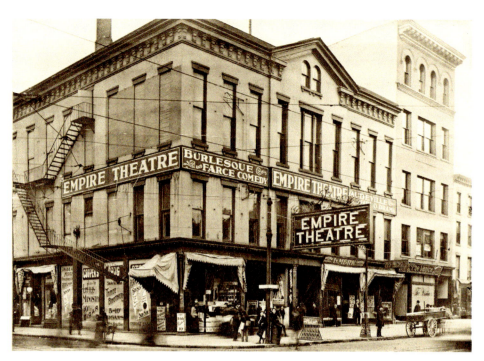

MAIN AND CLINTON: The Empire Theatre, the burlesque and vaudeville venue earlier known as the "Wonderland," showed the first motion pictures to Rochester audiences in 1896. After the original Sibley, Lindsey and Curr store burned in 1904, a five-story flagship department store was built at the former theater site. From its Tea Room to Toyland, Sibley's represented elegance. Its large, street-level windows filled with stunning displays drew eager crowds, particularly at Christmas time. Since the store's closure, the building has housed the Damon Campus of Monroe Community College. WinnCo is renovating the space into offices and apartments with a rooftop garden. (*Both photographs from the Collection of the Rochester Public Library Local History & Genealogy Division*)

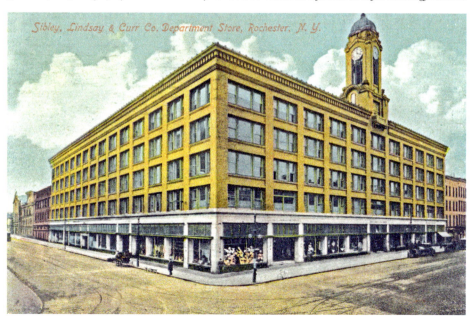

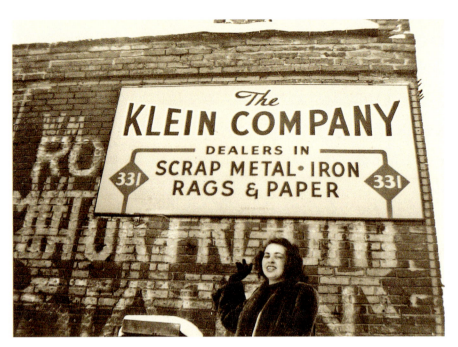

THE ART OF METAL: Klein Steel began as an Oak Street junkyard established by Jacob Klein and his son Arnold in 1946. His wife, Lenora, is pictured above and Arnold's son, Joe, grew up sorting metal in the yard, and was later put in charge of selling the usable materials. In 1969 the company decided to focus on selling difficult to find steel products. Since this rebranding and several factory moves, Klein Steel has gone on to ship 250-300,000 pounds of steel a day to industrialists and artists alike. The corporation's headquarters on Vanguard Parkway is adorned with the visually spectacular "Threshold" by local modernist sculptor, Albert Paley. (*Courtesy of Klein Steel*)

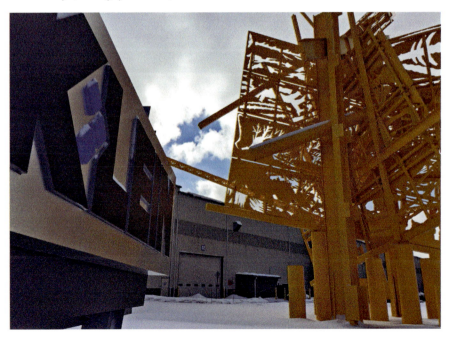

EDUCATIONAL INSTITUTIONS

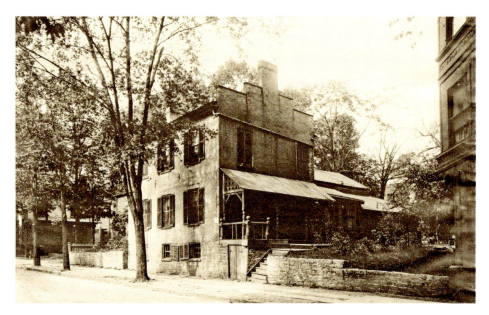

RIT'S ROOTS: It was not until 1818 that Colonel Nathaniel Rochester moved his family to his namesake town, Rochesterville. His brick home was located at the corner of Spring and South Washington Streets. For thirteen years he played a key role in the nascent city's development. The house was torn down in 1908 to make way for the Claude Bragdon-designed Bevier Building. Donated by art patron, Susan Bevier to the Rochester Athenaeum and Mechanic's Institute School of Art and Design (now RIT), the building is now in the process of restoration and will house apartments and a large office space. (*Top photograph from the Collection of the Rochester Public Library Local History & Genealogy Division. Bottom photograph courtesy of City of Rochester, New York*)

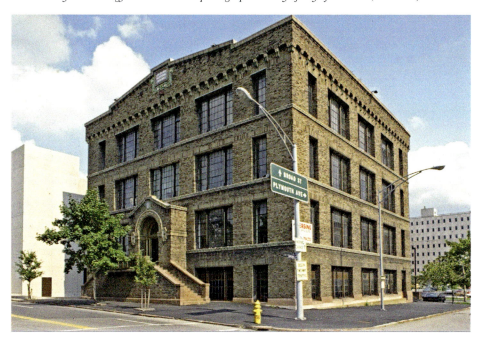

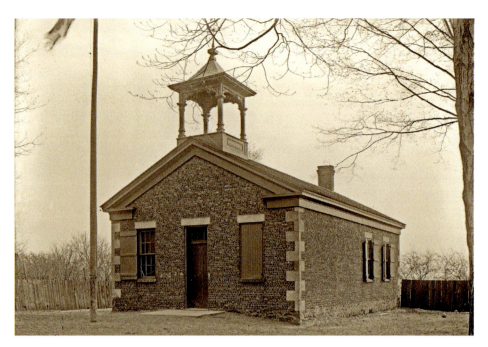

REGIONAL STYLE: This one-room cobblestone schoolhouse was built in 1844 at the intersection of Culver Road, Bay Street and Merchants Road when the area was still part of the town of Irondequoit. Cobblestone architecture is unique to the eastern Great Lakes region. The wave-rounded stones were plentiful and often collected by the whole community when a school or church was being constructed. The little schoolhouse stood here until 1917. The last remaining cobblestone building in the city, the Lockwood-Alhart House, is located a few blocks south on Culver Road. Today, a Mini-Mart serves the neighborhood at the old school site. (*Top photograph from the Albert R. Stone Negative Collection, Rochester Museum & Science Center Rochester, N.Y.*)

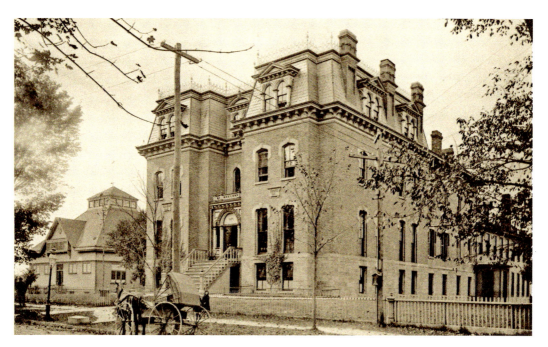

ROCHESTER SCHOOL FOR THE DEAF: Spearheaded by philanthropist Charlotte Perkins Gilman, whose daughter was born deaf, this specialized school opened in 1872 and took root at its current location on St. Paul Street in 1878. A pioneer in deaf education, the institution was responsible for developing both the "Rochester Method" of communication as well as the Lyon Phonetic System, created by volunteer teacher, Edmund Lyon. Lyon's manual went on to become an internationally used instructional text. Now serving 140 students a year, the school is recognized as one of the world's top institutions in the education of deaf and hard of hearing children. (*Top photograph from the Collection of the Rochester Public Library Local History & Genealogy Division*)

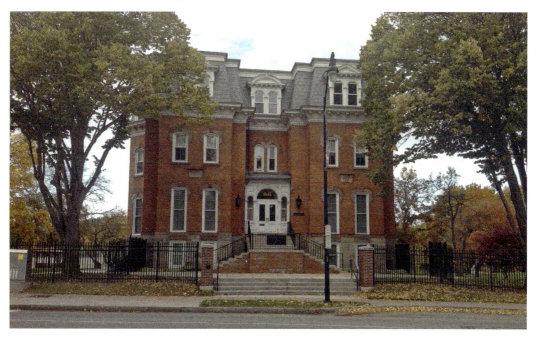

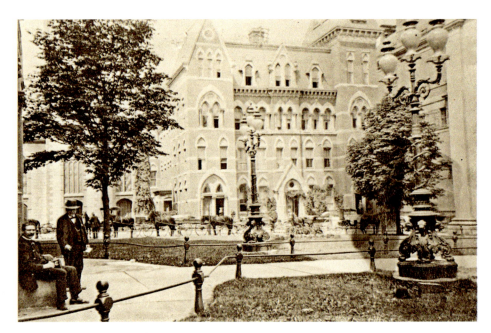

OLDEST LOCAL HIGH SCHOOL: This unique red brick Gothic style building at 13 South Fitzhugh was the first of the City School District's high schools. Designed by architect Andrew Jackson Warner, the Rochester Free Academy was constructed in 1873 on the site of a very early one-room schoolhouse. Over the years, the edifice has housed City offices, the Board of Education, and a popular restaurant. It has now been carefully restored and repurposed by George Traikos into loft-style apartments and retail space. The Free Academy is listed on the State and National Registers of Historic Places. (*Top photograph from the Collection of the Rochester Public Library Local History & Genealogy Division. Bottom photograph courtesy of City of Rochester, New York*)

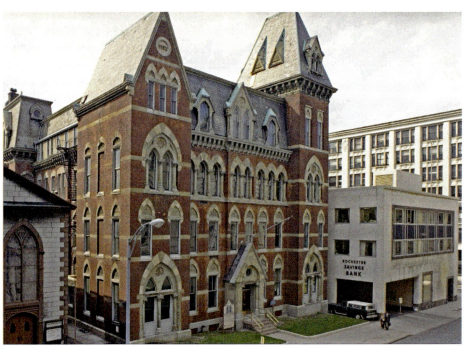

CORNER OF EAST AND GOODMAN: Hulbert Harrington Warner made a fortune peddling his "Safe Liver Cure." In 1879 he built his mansion to resemble a German castle on the Rhine. The City Municipal Museum, organized in 1912, had been located at Edgerton Park. With a donation from Edward Bausch, a renamed museum opened at the Warner home site in 1942. In addition to its collection of fossils, dioramas, and Native American and local history objects, the Rochester Museum and Science Center features hands-on learning in science and technology. The institution includes the Strasenburgh Planetarium, Eisenhart Auditorium, schools, camps and classes in a park setting. (*Both photographs from the Collection of the Rochester Public Library Local History & Genealogy Division*)

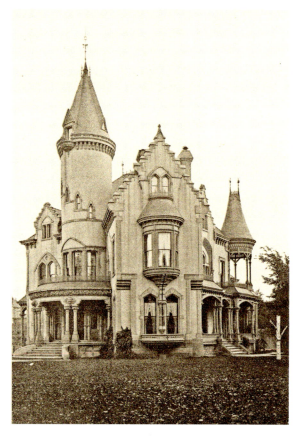

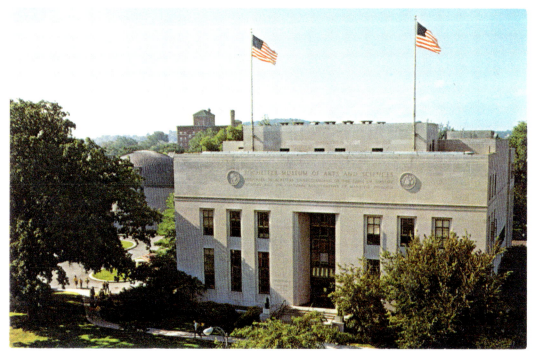

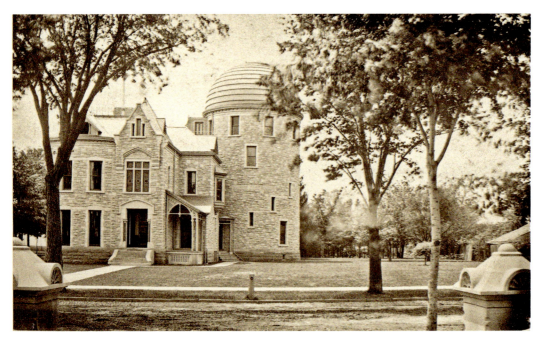

STAR GAZING CENTER: The first institution of its kind open to the public, the Warner Observatory was built in 1882 on East Avenue near Arnold Park by H. H. Warner, Rochester's "Patent Medicine King." Professor Lewis Swift, a local amateur astronomer, discovered several comets and nebulae through its twenty-two-foot telescope. Admission cost twenty-five cents or a wrapper from a package of Warner's Safe Liver Cure. After Warner's bankruptcy, Professor Swift secretly dismantled the telescope and brought it to California where the night sky was brighter. The chapel of the Third Presbyterian Church, a pioneer institution noted for social reform and outreach, now graces this site. (*Top photograph from the Collection of the Rochester Public Library Local History & Genealogy Division. Bottom photograph courtesy of Mike May*)

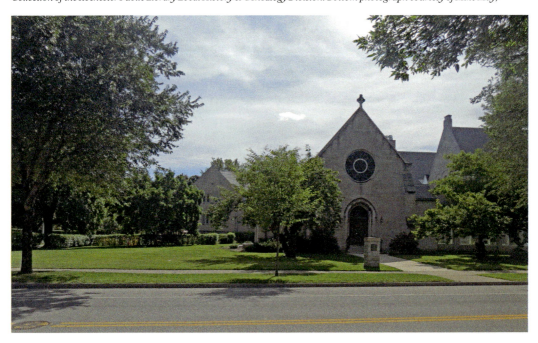

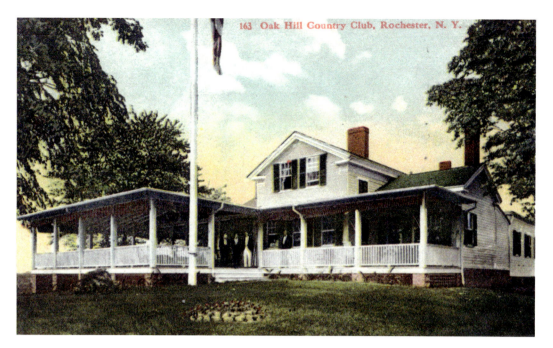

COURSE TO COURSES: As early as the 13th century, Algonquins inhabited the land that now comprises the University of Rochester's River Campus. Initially home to the Oak Hill golf course, whose clubhouse occupied the western edge the Eastman quadrangle in the early 1900s, the university moved to this location—its third—in 1930. Comprising just twelve edifices and an all-male student body when it opened, the co-ed campus has grown to include 158 buildings and Strong Memorial Hospital. The city's top employer and a prestigious educational institution, the University of Rochester has helped fuel the local economy while producing internationally-recognized innovative research. (*Top photograph from the Collection of the Rochester Public Library Local History & Genealogy Division. Bottom photograph courtesy of the University of Rochester*)

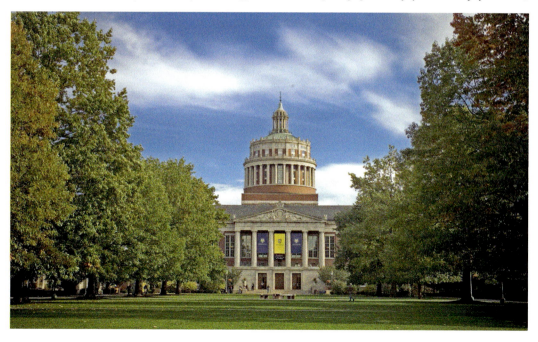

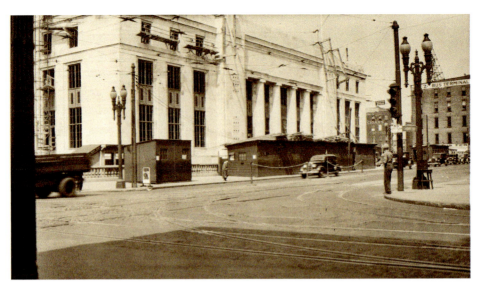

RUNDEL MEMORIAL BUILDING: The Central Library's namesake, Morton W. Rundel, was a modest art dealer who was not well known during his lifetime. George Eastman's cousin, Rundel had the foresight to buy Kodak stock at an early date, leaving him incredibly wealthy at the time of his death in 1911. He bequeathed a substantial amount of his fortune to the City for the library's construction, which eventually opened in 1936. Built in the midst of the Great Depression, the impressive granite and limestone structure with a capacity of 830,000 books was one of 34,000 American public works projects completed under the Roosevelt administration. (*Top photograph from the Collection of the Rochester Public Library Local History & Genealogy Division. Bottom photograph courtesy of the Rochester Public Library*)

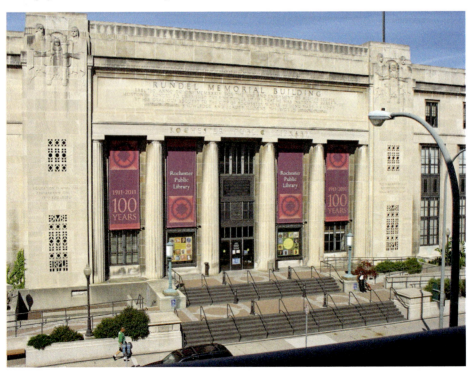

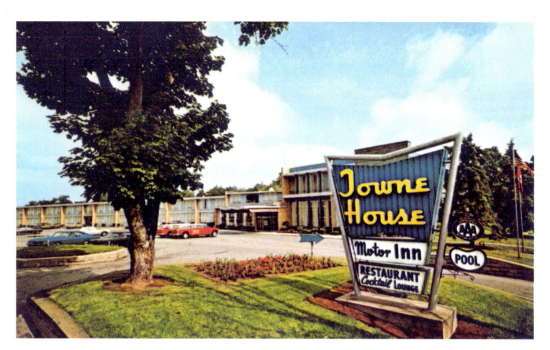

TOWNE HOUSE TO COLLEGETOWN: An entire village has sprung up at the intersection of Mt. Hope and Elmwood Avenue. Anyone who attended the University of Rochester in the 1950s and 1960s will remember the Townhouse Motor Inn which proudly featured televisions in every room, a pool, cocktail lounge and 24-hour switchboard service. The University of Rochester owned this property and was the driving force behind this extensive neighborhood makeover designed to make life easier for students, Strong Hospital staff and the local community. In addition to the school's Barnes and Noble bookstore, the complex includes restaurants, bakeries, offices, apartments, parking and a Hilton Hotel. (*Top photograph from the Collection of the Rochester Public Library Local History & Genealogy Division. Bottom photograph courtesy of Neoscape and the University of Rochester*)

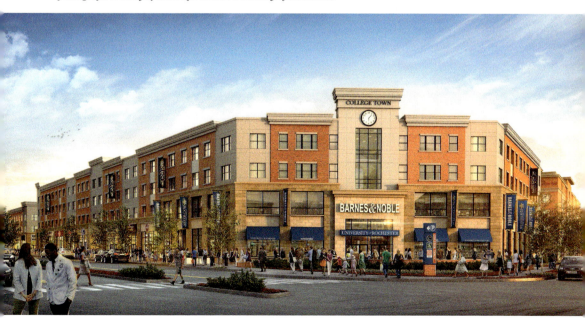

ETHNICITY, RELIGION, AND NEIGHBORHOODS

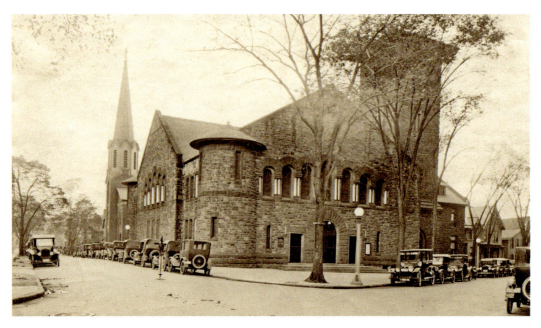

DOWNTOWN TEMPLE: Originally founded by twelve members in 1848, B'rith Kodesh serviced Rochester's growing Jewish community in the 19th and early 20th centuries. The city's first Jewish immigrants arrived from Germany in the 1840s. Succeeding waves of Russian and Eastern European Jews helped the congregation swell to over 250 members by the 1890s, creating the need for a larger temple. The resulting Romanesque structure on the corner of Gibbs Street and Grove Place suffered a fire in 1909, but the congregation rebuilt and remained at this site until relocating to Brighton in 1962. Modern townhouses now occupy the historic corner. (*Top photograph from the Collection of the Rochester Public Library Local History & Genealogy Division*)

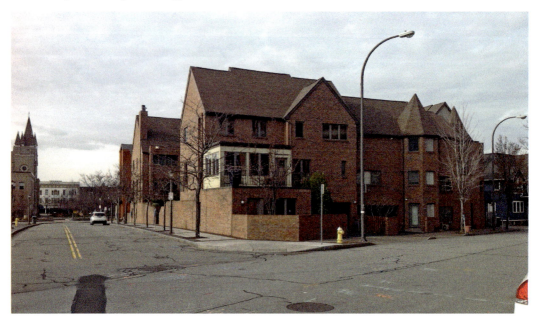

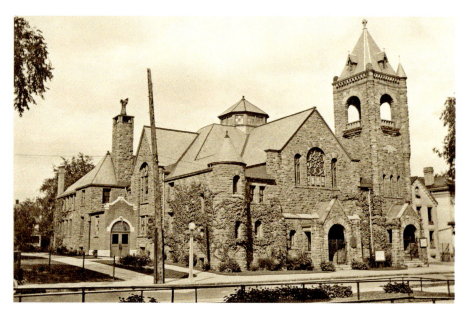

CORNER OF EDINBURGH AND FREDERICK DOUGLASS: Founded by a largely Scottish immigrant populace in 1852, the congregation of the Corn Hill Methodist Episcopal Church experienced a demographic shift as the area welcomed African American migrants in the 20th century. Civil Rights leader Malcolm X would give his last speech here before his assassination in 1965. Rechristened as the Corn Hill AME Zion Church in 1969, the church later suffered misfortune – a series of fires that remain unsolved today. The last fire in 1971 left little but the building's exterior shell, which along with an addition in the back, now houses the End Time Deliverance Ministry. (*Top photograph from the Collection of the Rochester Public Library Local History & Genealogy Division*)

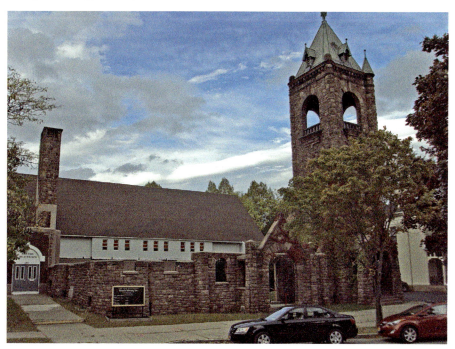

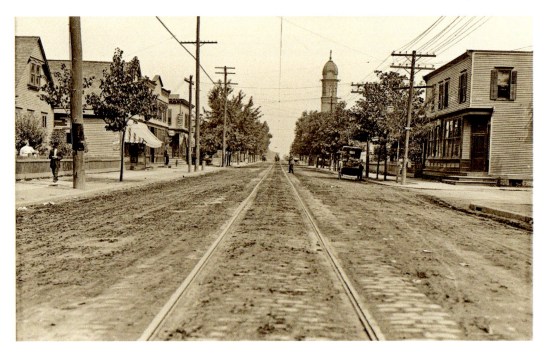

POLISH TOWN: This stretch of Hudson Avenue north of Sobieski Street was for many years a mainstay of Rochester's "Little Poland." Polish Immigrants, who began arriving to Rochester *en masse* after the 1860s, helped develop this northeastern section of the city, making their mark through a variety of mom and pop shops like Radomski's bakery and the area's crown jewel, St. Stanislaus Kostka Church. A multicultural population now resides along this section of Hudson Avenue, but the iconic church and Slavic cross-street names serve as a reminder of the neighborhood's Polish roots. (*Top photograph courtesy of City of Rochester, New York*)

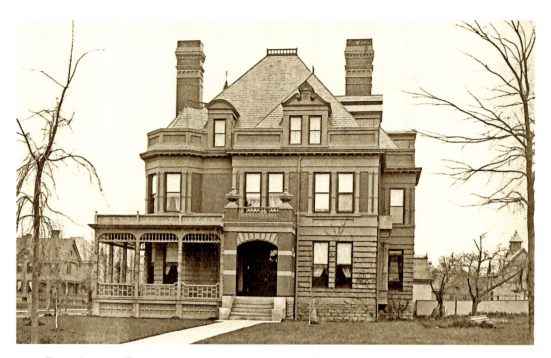

EAST AVENUE ELEGANCE: Originally the site of the Old Union Tavern and Ale House, the corner of East Avenue and Vick Park A has been home to this Queen Anne mansion since 1883. Built for railroad and building contractor, Henry Ellsworth, the estate joined a host of other opulent homes on the preferred boulevard of Rochester's elite. Over the course of the 20th century, many of the avenue's wealthier residents removed to suburban climes and most of their former homes were repurposed. Some became the headquarters for local clubs while others, such as Ellsworth's, were renovated into luxury apartments. (*Top photograph from the Collection of the Rochester Public Library Local History & Genealogy Division*)

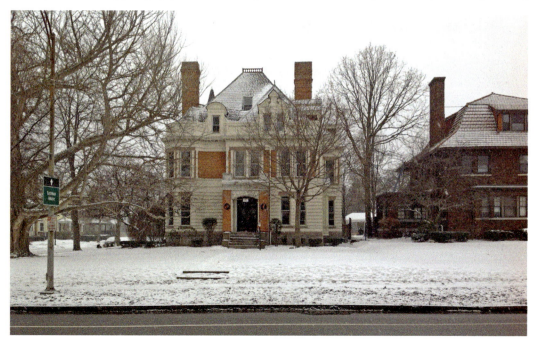

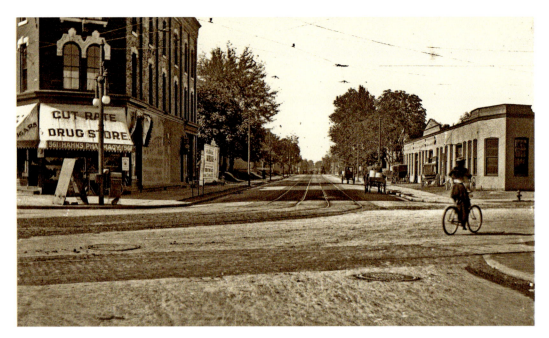

TRIANGULAR TRIBUTE: The wedge-shaped brick building at the intersection of Lyell, Lake and Smith Street is referred to as a flatiron because of its resemblance to the famous Flatiron Building in New York City. *Circa* 1899, George Hann's Pharmacy occupied this structure and R. J. Smith's carriage and bicycle shop stood across the street. While the former Smith building is still supporting transportation as a Cole Muffler Shop, the Flat Iron Café offers jazz and comedy as well as salsa and swing dance lessons. A venue for up and coming local musicians, the cafe is located in one of the city's most culturally diverse neighborhoods. (*Top photograph courtesy of City of Rochester, New York*)

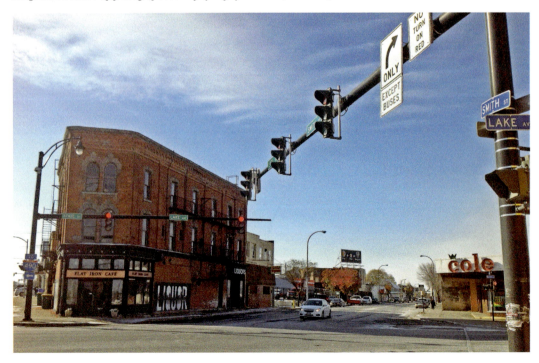

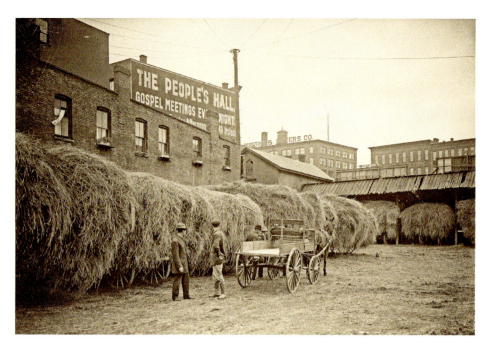

EARLY SHOPPING DISTRICT: A riverside road lined with meat markets, saloons, and shops of all kinds, Front Street was once Rochester's busiest retail center. One of the avenue's drawing cards was the hay market, which functioned as a gas station in the pre-automobile age, providing the means to "fuel" the city's horses. An essential site for one-stop shopping in the 19th century, the vibrant street grew increasingly run down over the years and was scheduled for demolition in 1965 as part of an urban renewal initiative. Genesee Crossroads Park now occupies the land where a myriad of Front Street businesses once stood. (*Top photograph from the Albert R. Stone Negative Collection, Rochester Museum & Science Center Rochester, N.Y.*)

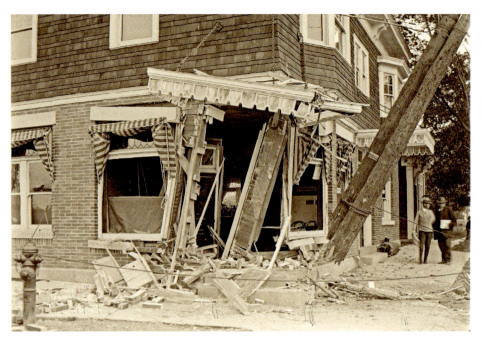

CRASH ON THE CORNER: Staib's Saloon on the northwest corner of Winton and Blossom Roads was barely open a year before tragedy struck. At midnight on September 22, 1913, a Pay-as-You-Enter streetcar derailed from its tracks and crashed head first into the entrance of the café while the proprietor and his wife were sleeping upstairs. Although the saloon weathered the crash, it did not survive the enactment of Prohibition in 1920. The streetcar line was eliminated not long after the 18th Amendment's repeal. The North Winton Village corner would later host Spiros' Grill before being converted into a gas station in 1959. (*Top photograph from the Albert R. Stone Negative Collection, Rochester Museum & Science Center Rochester, N.Y.*)

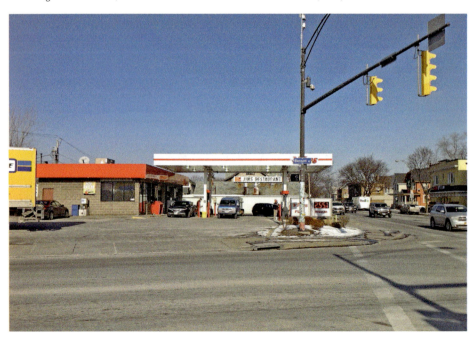

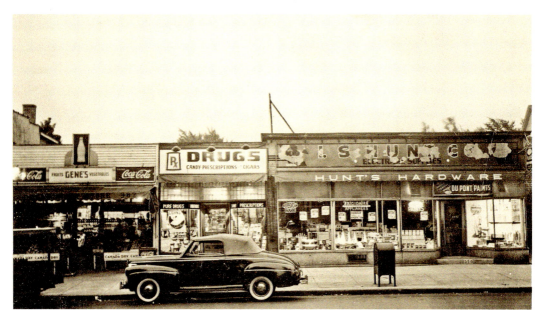

OVER A CENTURY OF SERVICE: Hunt's Hardware has celebrated over one hundred years in the 19th Ward. Isaac Hunt started his Thurston Road business in 1914, not far from the Megiddo Church that sparked the neighborhood's growth. Over the years, the shop has also served as a post office, pharmacy, grocery, library, craft shop, appliance center and at Christmas time, a toy store. In 1989 Hunt's commemorated its long history with a charming street-side makeover. Still a family business, Hunt's continues to meet the needs of an even wider community as one of the few independent hardware retailers that provides knowledge as well as service. (*Courtesy of Hunt's Hardware*)

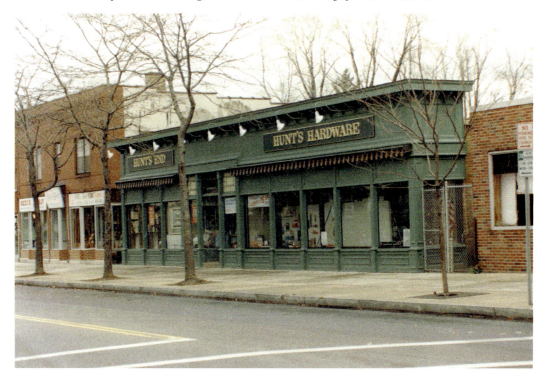

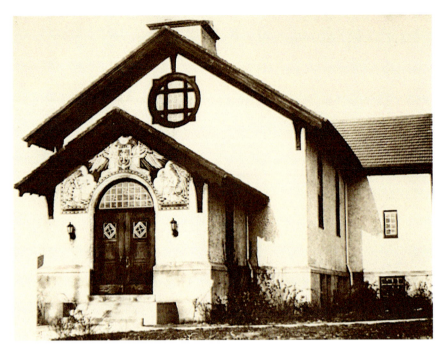

UNIQUE CHAPEL: This charming and distinctive little church at 766 West Broad Street was designed by Claude Bragdon in 1915. The original congregants were Waldensians, Italian immigrants from northern Italy who did not share their countrymen's Roman Catholic faith. The church was adorned with brightly colored frescoes. Today, the building is home to the Christ Temple Apostolic Faith Church and its surrounding neighborhood is largely Latino. Sahlen Stadium next door, opened in 2006 and is home to the Rochester Rhinos and Western New York Flash soccer teams as well as the Rochester Rattlers major league lacrosse team. (*Top photograph courtesy of Michael Leavy*)

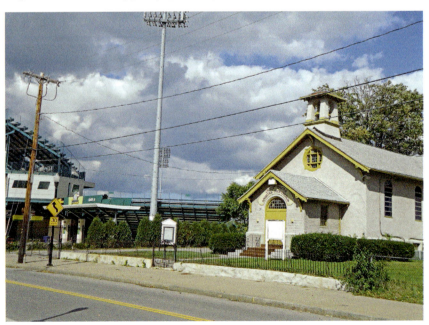

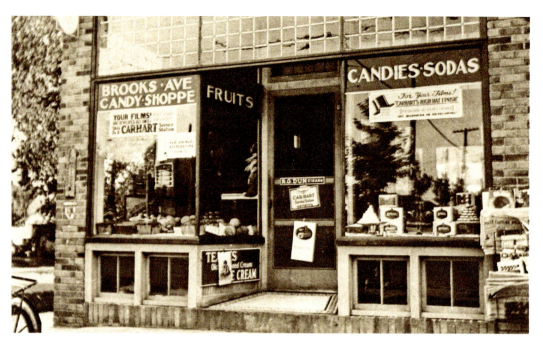

SOUTHWEST COMMUNITY SWEET SHOP: Though officially named the Brooks Avenue Candy Kitchen, this 19th Ward institution on the corner of Brooks and Thurston was colloquially known as "Louie's." Proprietor Louis Throumoulus, emigrated from Greece in the early 20th century and opened his namesake shop in 1925 after gaining experience working at local candy stores and soda fountains. Louie passed the popular business on to his son, Peter, who ran it from 1970 until it closed in 1997. A replica of the iconic confectionary continues to delight visitors of the Strong Museum, while its former storefront now hosts Holley's Café and Catering. (*Top photograph from the Collection of the Rochester Public Library Local History & Genealogy Division*)

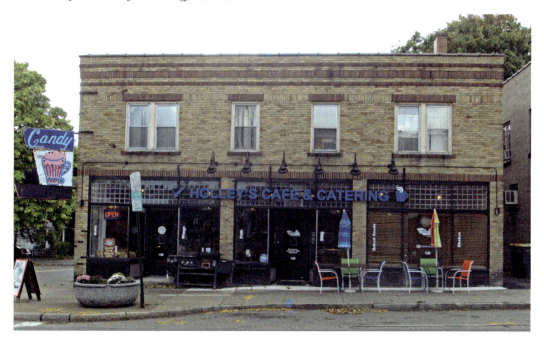

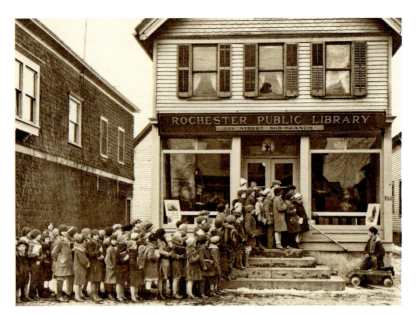

LINE OUT THE DOOR: A fixture of the Dutchtown neighborhood, this Jay Street sub-branch near Colvin Street served a largely Italian-American population when it opened in 1928. Established in areas not served by libraries, sub-branches were limited service operations and as a result, were quite busy during their open hours. Though most of these mini-libraries had a staff of one or two assistants, this popular location necessitated five per shift. The sub-branch also had a police officer on staff to maintain order among the throngs of children waiting outside. Closed in 1958, the library building has housed both businesses and residences in subsequent years. (*Top photograph from the Collection of the Rochester Public Library Local History & Genealogy Division*)

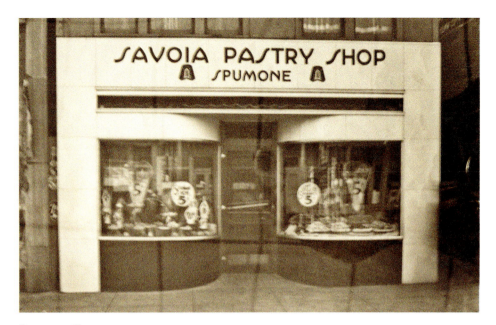

SICILIAN SPECIALTIES: Savoia Pastry Shoppe at 2267 Clifford Avenue is one of the city's few remaining family-owned Italian-style bakeries. A destination stop for people from all over the community for holiday parties and weddings, the store often sees long lines of people snaking out to the sidewalk. It was founded in 1929 by Michael and Theresa Petrantoni, hard-working and talented immigrants from Sicily. For almost half a century, Savoia has been at its present location. Owners Kathy and George Privitera state that they are most famous for their tea cookies, cookie cakes, and of course, cannolis. (*Courtesy of Savoia Pastry Shoppe*)

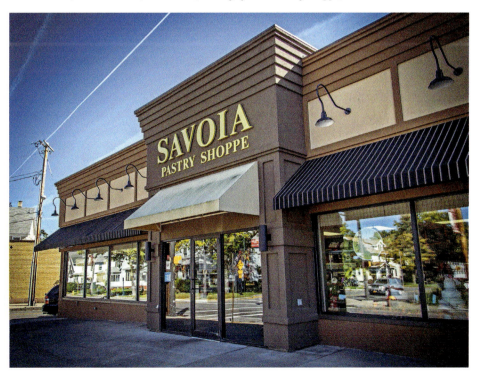

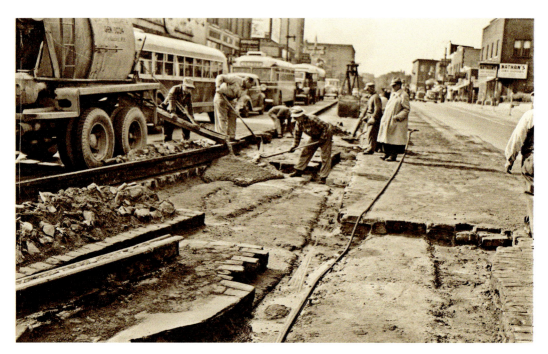

BEECHWOOD BOULEVARD: Goodman Street, which began as the lane adjoining George Goodman's farm, was once the city's eastern boundary. This section below Webster Avenue forms part of the Beechwood neighborhood initially settled by German immigrants. A major North-South thoroughfare, the street made a logical location for a streetcar route in the early 20th century. Though Beechwood's motto is "where roots run deep," the same could not be said of its local trolley route. Removed in 1943, the tracks that once carried bustling streetcars were replaced with the bus-friendly paved surface that now forms Goodman Street. (*Top photograph courtesy of City of Rochester, New York*)

Arts and Recreation

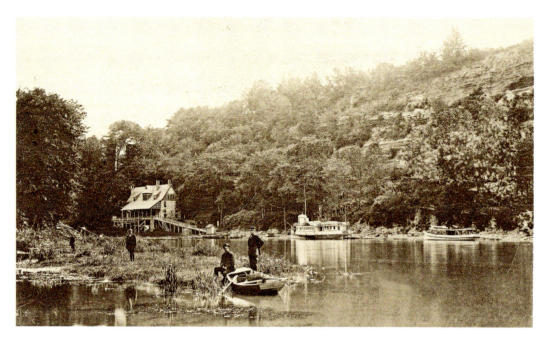

EARLY RIVERSIDE INN: One of the first summer hotels in the Rochester area, the Glen House, built in 1870, was located on the western bank of the Genesee River just north of where the Driving Park Bridge is today. Because the hotel was located about 100 feet below street level, a hydraulic elevator powered by the nearby waterfalls was built for guests. Steamboats that plied the Genesee River to the lake would stop at the inn. On May 4, 1894, the proprietor and his relatives watched as a fire burned the hotel to the ground, killing the family's grandmother. Only random stones remain. (*Top photograph from the Collection of the Rochester Public Library Local History & Genealogy Division*)

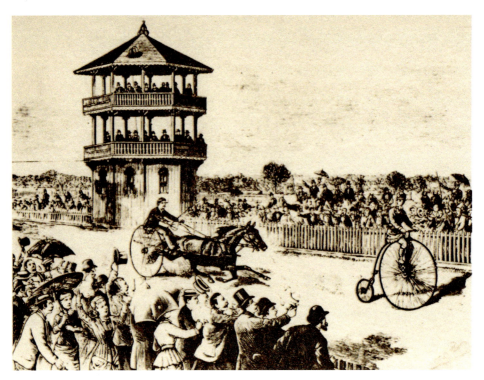

A DAY AT THE RACES: The Rochester Driving Park opened in August 1874. Thousands were attracted to the racecourse located north of Driving Park Avenue. The Dewey Avenue jog remains from the boundary. The mile long, oval track was considered exceptionally fast and drew notable racehorses, bicycle races and circuses. Buffalo Bill Cody, who moved to Rochester in 1875, also made regular appearances at the park. A 19th century *Democrat and Chronicle* article described the "Indians, cowboys, soldiers, Mexicans, Cossacks from Siberia and the Last of the buffaloes" of Cody's Wild West Show. Closed in 1895, the former park site is now a residential area. (*Top photograph from the Collection of the Rochester Public Library Local History & Genealogy Division*)

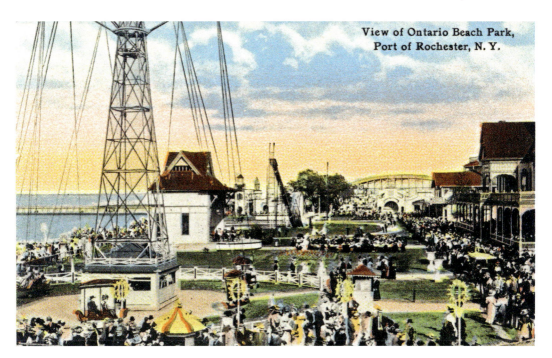

ONTARIO BEACH PARK: Rochesterians began pitching tents at this lakeside site in 1865, but it wouldn't become a leading resort area until the 1870s. Attendance later swelled thanks to trolley line access and the addition of a variety of rides and attractions such as the Virginia Reel and the Loop of Death. Billed as the "Coney Island of Western New York," at the turn of the century, the park was rebranded as a bathing beach when the City took over its operation in 1917. The beach remains a popular destination, but the Dentzel carousel is the only reminder of the park's origins. (*Top photograph from the Collection of the Rochester Public Library Local History & Genealogy Division. Bottom photograph courtesy of City of Rochester, New York*)

HIGHLAND PARK: In 1887 nurserymen George Ellwanger and Patrick Barry made a gift to the City of Rochester of twenty acres to be made into a municipal park. Designed by the "Father of American Landscape Architecture," Frederick Law Olmsted, the spacious park included the popular Children's Pavilion, an open air pagoda from which miles of the area's countryside could be viewed. John Dunbar, the Assistant Park Superintendent, planted over one hundred varieties of lilac bushes on the park's grounds, including some that he developed himself. His legacy made the park and its Lilac Festival known worldwide today. (*Top photograph from the Collection of the Rochester Public Library Local History & Genealogy Division. Bottom photograph courtesy of City of Rochester, New York*)

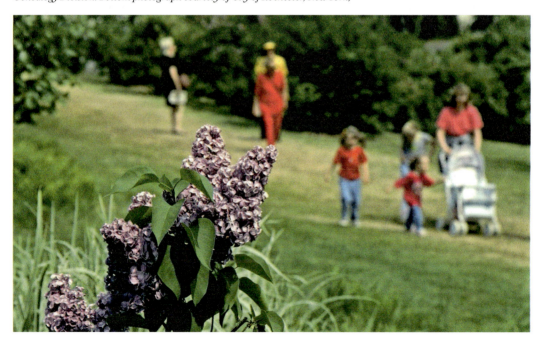

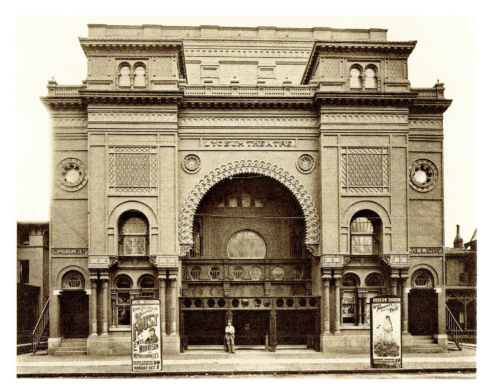

PREMIER PLAYHOUSE: Featuring an Alhambra-inspired design, the Lyceum was Rochester's top theater at the turn of the century. Built in 1888, the well-respected South Clinton Avenue establishment helped Rochester land the role as a tryout town for plays and musicals. Though for years it was a preferred destination among the city's cultural elite, the Lyceum began to face competition in the 1920s from newer playhouses as well as the rising popularity of films. The venue shut its doors in 1934 and like many of Rochester's downtown theaters, was replaced with a parking lot. The greenspace of the Windstream campus now occupies the former Lyceum site. (*Top photograph from the Collection of the Rochester Public Library Local History & Genealogy Division. Bottom photograph courtesy of Mike May*)

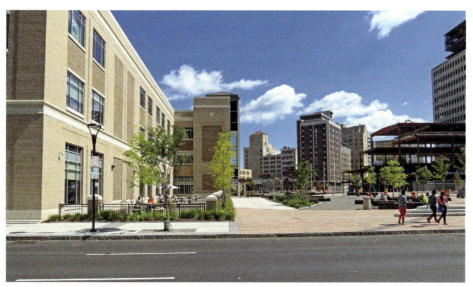

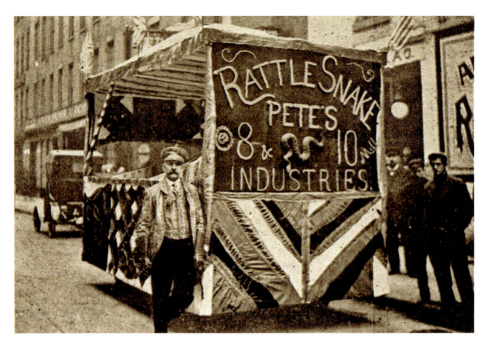

WEIRD WATERING HOLE: Undoubtedly one of Rochester's most unusual turn-of-the-century attractions, Gruber's Saloon opened on Mill Street in 1893. Though locals and tourists alike came to the saloon for its fine wines and cigars, the establishment's real draw was its museum of curiosities, which included twenty-five live snakes, a stuffed alligator and a variety of reptiles. Proprietor "Rattlesnake Pete" Gruber, who frequently sported a suit made of snakeskins, handled the reptiles with his bare hands and peddled their oils as a cure for various ailments. Gruber's establishment closed upon his death in 1932 and its former Mill Street site vanished under urban renewal. (*Top photograph from the Collection of the Rochester Public Library Local History & Genealogy Division*)

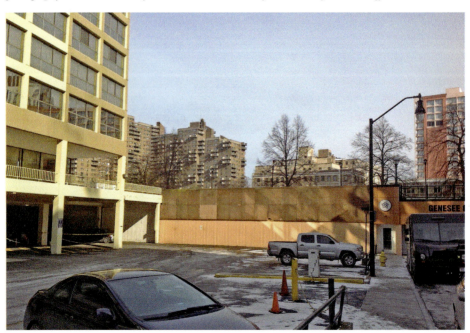

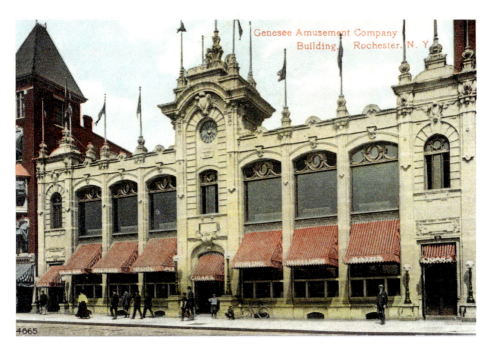

ENTERTAINMENT EMPORIUM: Taking up the better part of a street block, the Genesee Amusement Company on South Avenue was a nationally renowned institution. Opened in 1908, the spacious facility offered a wide variety of entertainments under one roof. Containing a roller skating rink, public bath house, a restaurant, a billiards hall, a movie theater and bowling alleys, the multipurpose establishment was deemed to be "one of the finest amusement plants in the United States," by *Leslie's Illustrated Weekly*. The company closed shop in 1940. Since the mid-1990s, the southeast corner of South and Broad has housed the Bausch and Lomb Library Building. (*Top photograph from the Collection of the Rochester Public Library Local History & Genealogy Division. Bottom photograph courtesy of Mike May*)

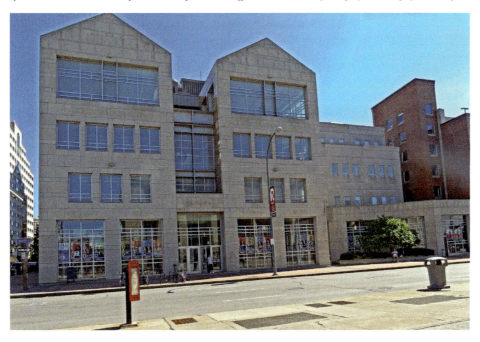

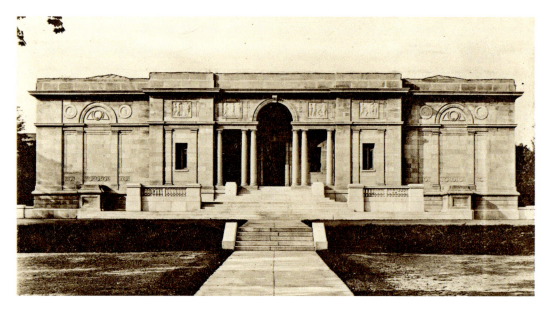

COMMEMORATIVE MUSEUM: Prominent Rochesterian Emily Sibley Watson funded the Memorial Art Gallery and the elegant, classical building that houses it in 1913. It was built as a monument to her son, James G. Averell, a young architect who died of typhoid. Its design was based on her son's drawing of a temple in Italy. The MAG is in trust to the University of Rochester and was originally part of the school's Prince Street campus. Recent gallery additions include the Centennial Sculpture Park, an outdoor showcase of public art. The sculpture pictured is "Unicorn Family" by celebrated artist, Wendell Castle. (*Top photograph from the Collection of the Rochester Public Library Local History & Genealogy Division*)

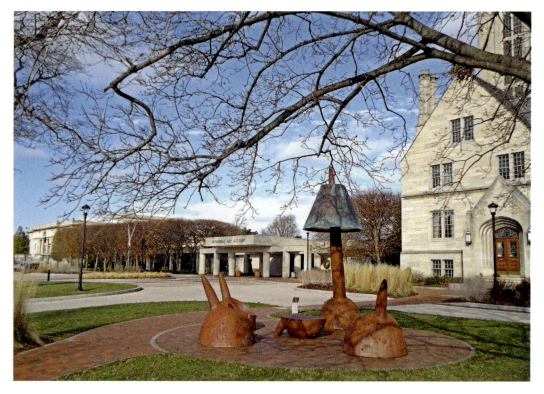

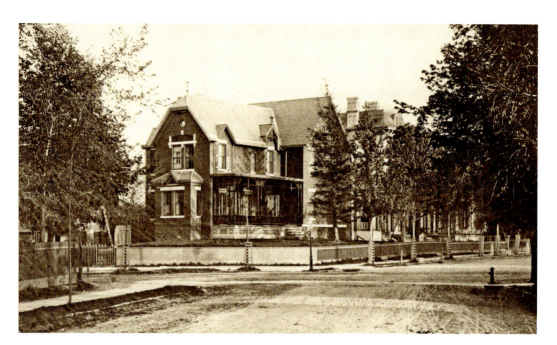

EASTMAN THEATRE: Once the location of Theodore Bacon's residence, the corner of Main and Gibbs has housed one of Rochester's most iconic structures since 1922. Part of George Eastman's plan to create both a music school and an auditorium to serve the local community, the Eastman Theatre initially showcased films and dance with orchestral accompaniment. Now the main hall for Eastman ensembles and the Rochester Philharmonic Orchestra, the opulent theater has welcomed a host of musical giants ranging from James Brown to Igor Stravinsky. Various renovations in the 2000s resulted in additional performance spaces, improved acoustics and an elegant Dale Chihuly chandelier. (*Top photograph from the Collection of the Rochester Public Library Local History & Genealogy Division. Bottom photograph courtesy of Eastman Theatre. Photographer: Kurt Brownell*)

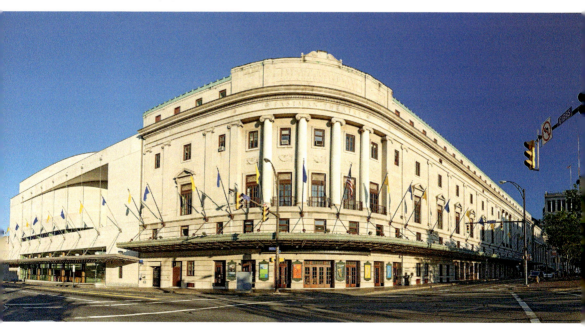

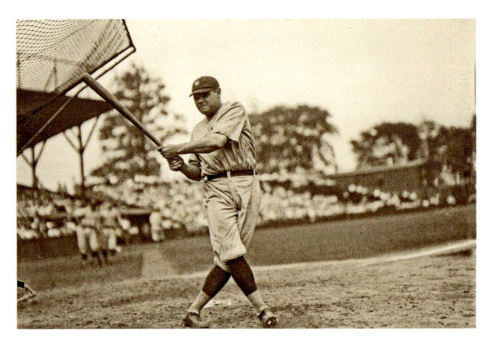

BATTER UP: Rochesterians have long been baseball enthusiasts. Large crowds watched Babe Ruth in a 1921 exhibition game between the Rochester Colts and the New York Yankees at the old Bay Street Baseball Park near McKinster Street. Many Rochester players have had notable careers. Ruth was succeeded at Yankee right field by Red Wing George Selkirk, an Emerson Street resident who graduated from Edison Technical High School. Our many ball parks, including Hague Street, Edgerton Park, Culver Field, and Silver Stadium on Norton Street have led to the retro-inspired, brick stadium, Frontier Field, built in 1997 for our Rochester Red Wings. (*Top photograph from the Albert R. Stone Negative Collection, Rochester Museum & Science Center Rochester, N.Y. Bottom photograph courtesy of Rochester Red Wings Baseball*)

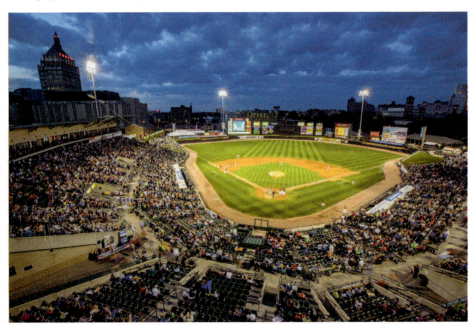

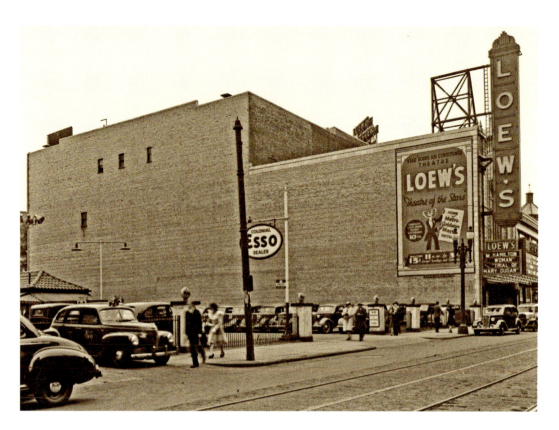

FROM FILMS TO PHOTOGRAPHIC PAPER: Despite its modest exterior, the Loew's Rochester Theatre on South Clinton Avenue was at one time the largest theater between New York City and Chicago. Opened in 1927, the ornate movie palace adorned with murals, chandeliers and bronze light fixtures, later served as a music venue in the 1950s, hosting performances by the likes of Nat King Cole. Facing competition from suburban multiplexes and the nearby entertainments of Midtown Plaza, Loew's Theater closed in 1964. Since 1968, the corner has been home to the city's tallest building hosting one of the city's biggest corporations, Xerox. (*Top photograph courtesy of City of Rochester, New York*)

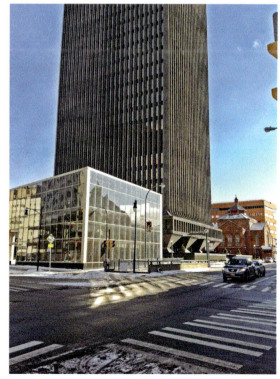

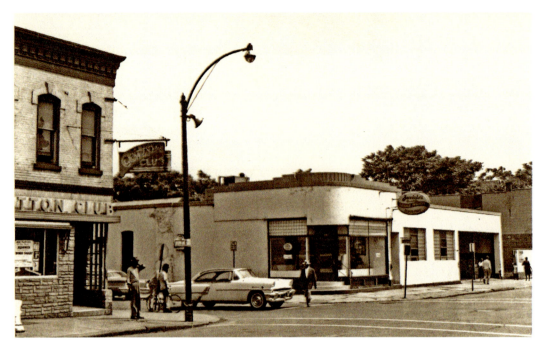

JAZZ ON JOSEPH AVE: Part of the historically multicultural 7th Ward neighborhood, the intersection of Joseph Avenue and Kelly Street once housed the original Zweigle's butcher shop as well as one of the city's noted music venues. Opened in 1942, the Cotton Club showcased local jazz and blues talent and drew touring artists like Roland Kirk and Bullmoose Jackson. The popular club and much of the surrounding area was torn down in the late 1950s as part of an urban renewal initiative. In the club's place, the city erected Chatham Gardens, a housing complex designed to be Rochester's first integrated residential community. (*Top photograph from the Collection of the Rochester Public Library Local History & Genealogy Division*)

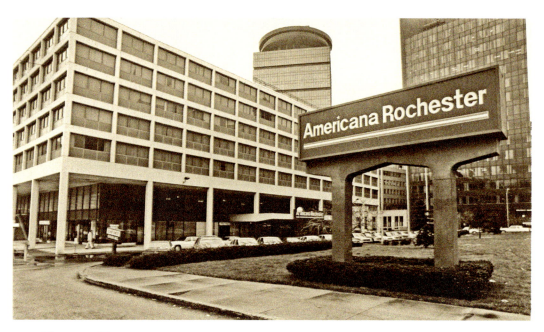

MUSICAL HOTEL: This State Street hotel built in the late 1960s has undergone several name and ownership changes, but its involvement with music has remained a constant. The Americana Hotel's proximity to the Community War Memorial made it a convenient lodging spot for touring acts, though it gained some notoriety in 1976 for being the site of David Bowie's infamous arrest. Since 2001, the Rochester Plaza has been the official hotel of the Xerox Rochester International Jazz Festival, and has hosted the festival's nightly jam sessions, drawing performances from amateur artists and jazz giants alike. (*Top photograph from the Collection of the Rochester Public Library Local History & Genealogy Division*)

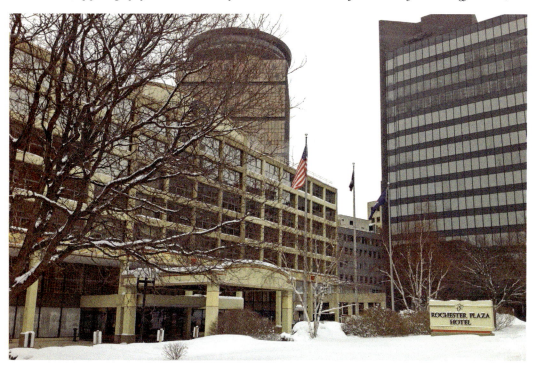

Repurposing Rochester

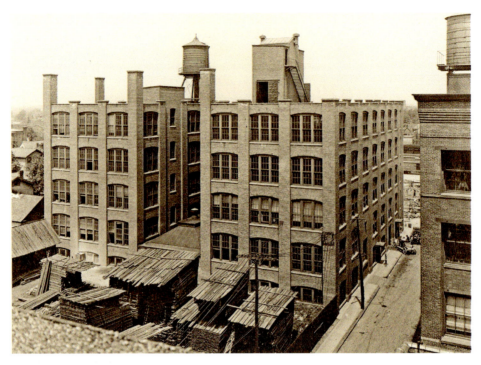

Carriages and Cars: The Cunningham Carriage Company, which straddled Canal Street to Litchfield Street, was once Rochester's largest industrial employer. Founded in 1838 by Irish immigrant James Cunningham, the firm initially crafted one-horse open sleighs and buggies, then specialty coaches such as the "Black Mariah" Funeral Hearse. From 1908 to 1938, the company produced luxury gasoline-powered roadsters and towncars for wealthy clients like Mary Pickford. They also manufactured Cunningham-Hall Airplanes, providing George Eastman with his first plane ride. Today, DePaul has transformed part of the complex into the seventy-one unit Carriage Factory Apartments, with an original Cunningham Brougham gracing the lobby. (*Courtesy of DePaul Properties*)

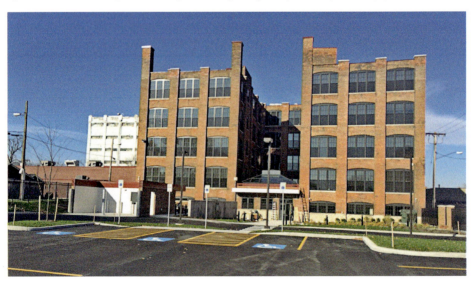

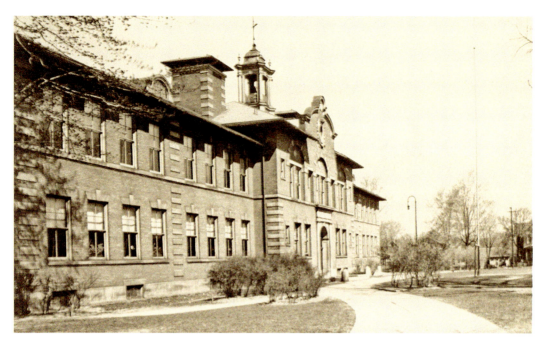

OLD SCHOOL, NEW USE: Initially known as the Munger School, the Horace Mann School #13 on Hickory Street was a fixture of the Southwedge community for many years. Founded in 1842, Horace Mann was designated as an integrated school in the 1850s before statewide integration went into effect in 1857, thanks in part to the influence of Frederick Douglass, whose younger children attended the institution. The school's growth required the construction of this J. Foster Warner-designed structure in 1903. Despite community protest, the school closed in 1979 due to declining enrollment. The building reopened as the Gregory Park Condominiums in 1982. (*Top photograph from the Collection of the Rochester Public Library Local History & Genealogy Division*)

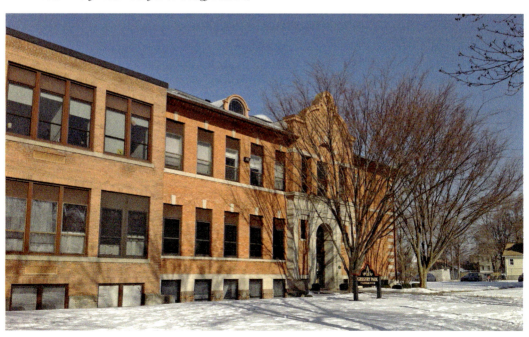

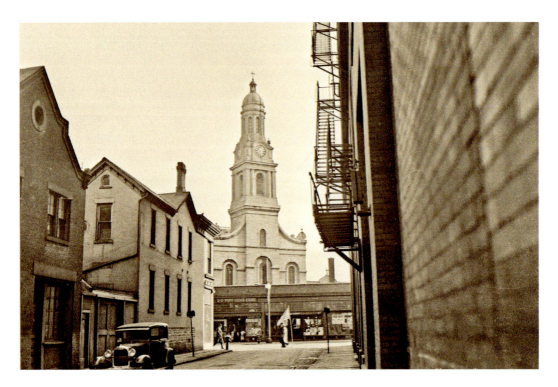

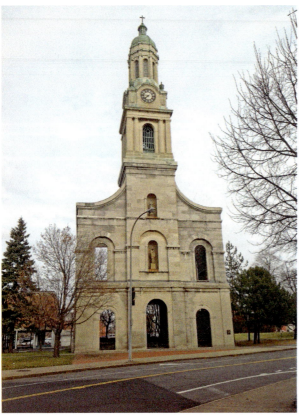

From Parish to Park: Built in 1846, St. Joseph's was the first church to cater to Rochester's growing German Catholic community. For a time, St. Joseph's was the city's tallest building and before the age of wristwatches, many locals, including George Eastman, kept time using the tower's clock. The parish's congregation dwindled in the 20th century as many of the city's Catholics relocated to the suburbs. The church suffered a further blow in 1974 when a devastating fire gutted the building's interior. St. Joseph's spirit was nevertheless saved when the Landmark Society of Western New York converted the site into a park in 1980. (*Top photograph from the Collection of the Rochester Public Library Local History & Genealogy Division*)

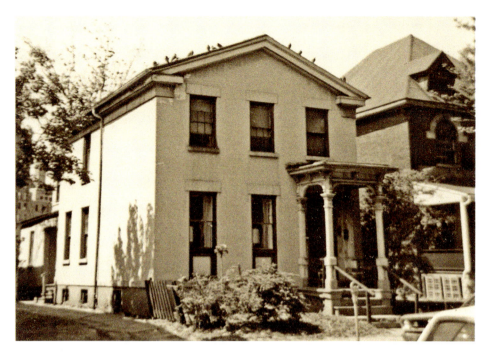

OLDEST HOUSE ON THE BLOCK: Dating from the mid-19th century, this Greek Revival-inspired brick house is the longest surviving building in the Andrews Street/Liberty Pole Way neighborhood. Though the house pictured on the right is still intact, it was uprooted in its entirety and relocated to Selden Street in the 1980s. According to local legend, the building that stayed behind was for some time a house of ill repute. It was later converted into Tara's Cocktail Lounge, a popular bar among the gay community. Since 2008, the historic structure has housed Abilene Bar and Lounge, one of the city's premier music venues. (*Top photograph courtesy of the Landmark Society of Western New York*)

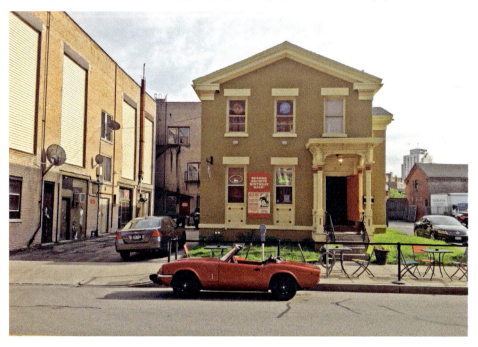

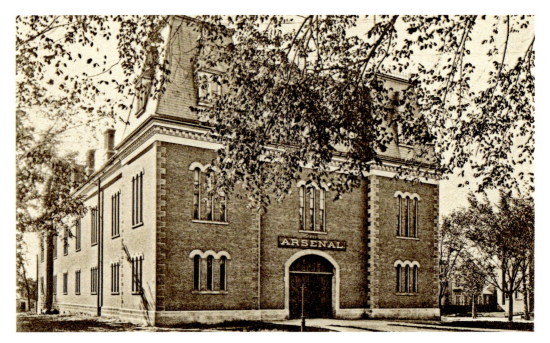

ARSENAL TO ARTS CENTER: The Arsenal Building, south of Washington Square Park, is listed on the National Register of Historic Places. Constructed in 1868 and later renamed Convention Hall, the venue hosted many memorable performances. Notably, the "King of Jazz," Paul Whiteman, presented "Rhapsody in Blue" here in 1924 with the song's composer George Gershwin, at the piano. Today, the building houses the GEVA Theatre. Founded in 1972, the venue is the most highly attended regional theater in New York State. The structure has been beautifully remodeled into two theaters and is known to not have a bad seat in the house. (*Top photograph from the Collection of the Rochester Public Library Local History & Genealogy Division. Bottom Photograph courtesy of GEVA*)

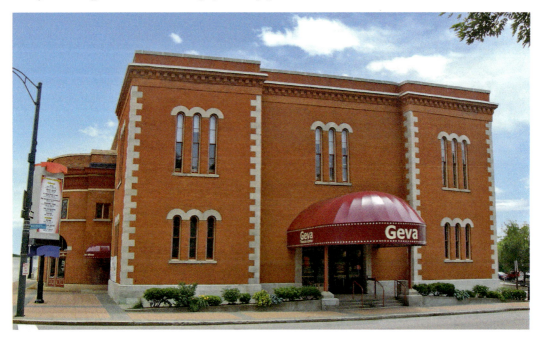

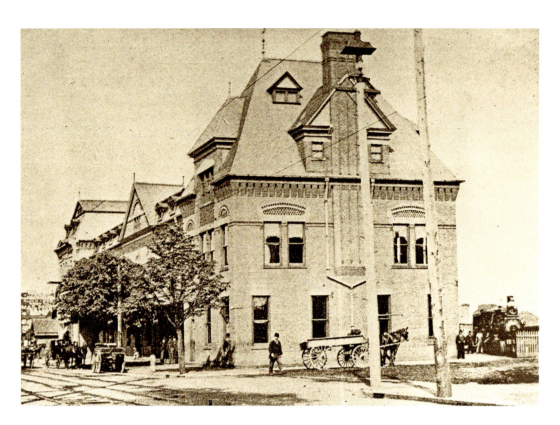

LOCAL DELICACY: The towers on either side of this fanciful red brick building at West Main and Broad Street are asymmetrical because they were built at different times. The older section, known as Pitkin's Building, once housed a daguerrean gallery. The Buffalo, Rochester and Pittsburgh Railroad station was added on to the structure in the 1880s. Today, it is home to Nick Tahou's Restaurant and the famous "Garbage Plate." Founded in 1918 by Alex Tahou and named for his son, the restaurant has attracted everyone from local students to touring rock stars and has been featured on television and in travel books. (*Top photograph from the Collection of the Rochester Public Library Local History & Genealogy Division*)

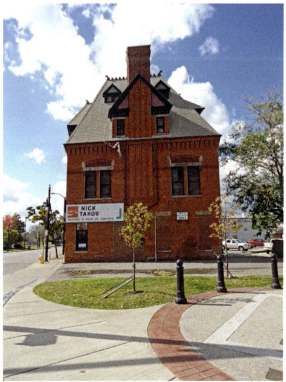

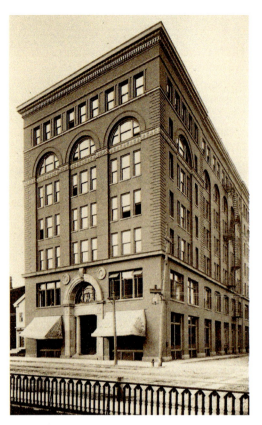

COLORFUL CLOTHING FACTORY: Constructed in 1893, this seven-story building on North Clinton Avenue once housed Michaels-Stern & Company. One of the largest firms in Rochester's men's clothing industry, the company was a significant employer of Russian and Polish Jewish immigrants at the turn-of-the-century. Operations ceased in 1972 and the company headquarters was repurposed as loft apartments. In 2013 the building's rear façade was emblazoned with a mural by Faith 47 as a part of Wall Therapy, an annual festival during which street artists from around the world adorn various Rochester landmarks with artwork in order to beautify the city's urban and industrial landscape. (*Top photograph from the Collection of the Rochester Public Library Local History & Genealogy Division. Bottom photograph courtesy of Fred Heier*)

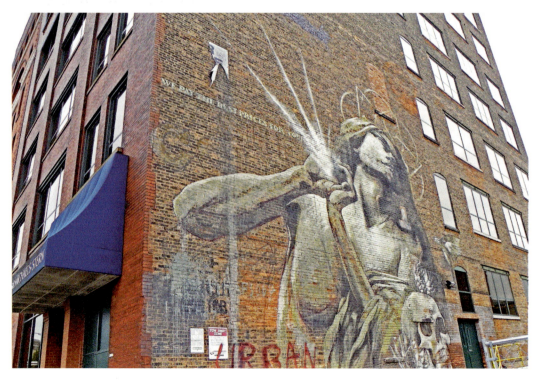

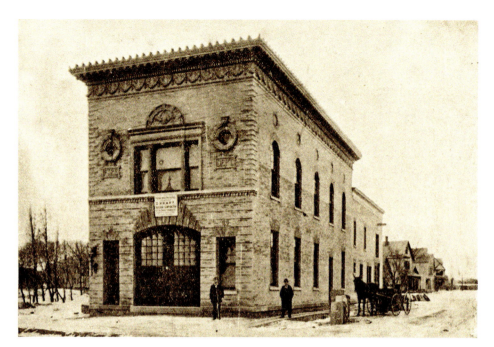

FIREHOUSE TO COOPERATIVE CENTER: This fire station on the corner of Monroe and Wilcox doubled in size within the first decade of its existence. Originally built in 1895, the firehouse expanded in 1904 in response to the city's increasing need for firefighters. Because they were designed to accommodate horses rather than vehicles and modern equipment, early firehouses such as this one were considered impractical by the mid-20th century. Closed in 1971, the old station took on new life when the Genesee Co-op moved in the following year. Initially a food buying cooperative, the non-profit evolved into a unique community and educational center. (*Top photograph from the Collection of the Rochester Public Library Local History & Genealogy Division. Bottom photograph courtesy of Mike May*)

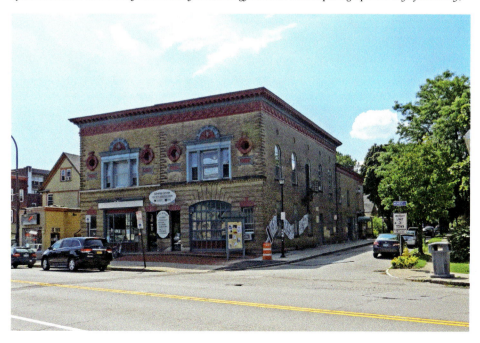

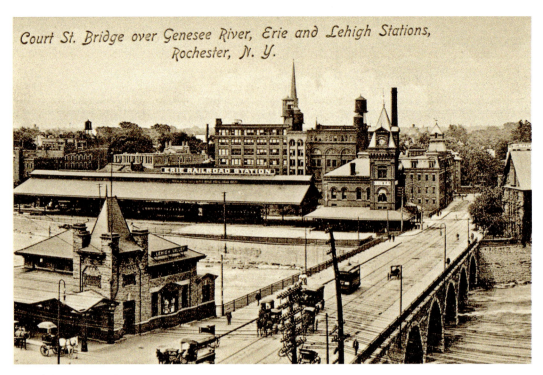

CORNER OF SOUTH AND COURT: The Lehigh Valley Railroad Station was the original occupant of the distinctive golden brick building with the tile roof overlooking the Genesee River. Built in 1905, the French chateau-like depot is now on the National Register of Historic Places. Though once a transportation hub with train, subway and canal boat access, the station closed in the 1950s and stood derelict until Max Farash restored it in the 1980s. It is currently home to Dinosaur Bar-B-Que Restaurant. The iconic eatery began as a biker food truck and is now famous for its authentic fare and live music concerts. (*Top photograph courtesy of City of Rochester, New York*)

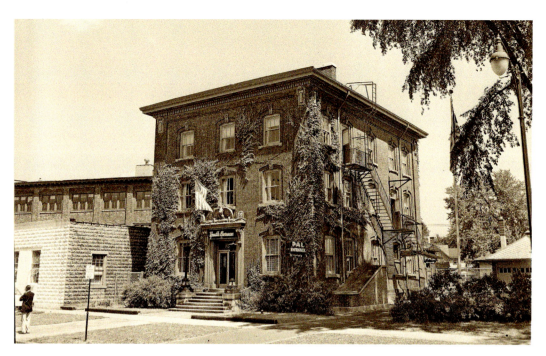

COMMUNITY CENTER: A police station from 1905 to 1948, this Claude Bragdon-designed building on University Avenue has served the Neighborhood of the Arts community in a variety of ways. Repurposed as the Police Athletic League headquarters in 1952, the precinct's former jail cell was converted into a boxing ring, while the building's offices were remodeled according to various themes including an "outdoor room" for boys and a doll room for girls. Though the youth program ended in 1958, the building carried on as a recreation center. Since 1985 it has been home to renowned independent bookstore and creative center, Writers and Books. (*Top photograph courtesy of City of Rochester, New York*)

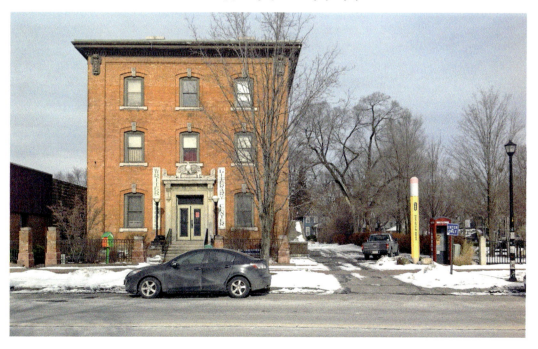

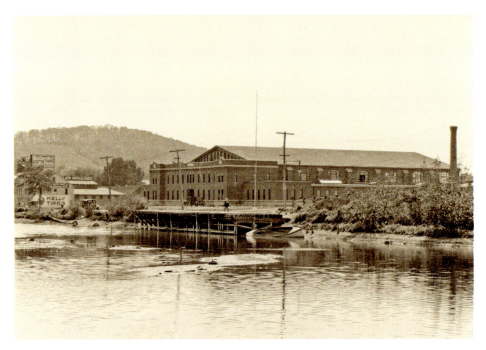

CULVER ROAD ARMORY: The New York National Guard Armory was built in 1918 for Troup H, the City of Rochester's first Cavalry Unit of World War I. The Armory was constructed near the eastern wide waters of the Erie Canal. Today the 490 expressway flanks the Armory on the former route of the canal. The property was sold at a state surplus auction in 2004 to developer, Fred Rainaldi, who envisioned a "modern museum of art" look to the remodel. The upscale tenants in 2015 include the popular restaurant Trata, offices, and retailers Arhaus, Fleet Feet and Alex and Ani. (*Top photograph from the Collection of the Rochester Public Library Local History & Genealogy Division*)

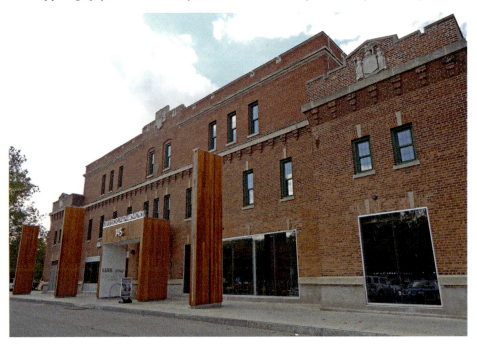

Bibliography

Books

A history of the brewery and liquor industry of Rochester, NY. Rochester, NY: Kearse Publishing Company, 1907.
Beaumont, Daniel E. *Preachin' the Blues: the life and times of Son House.* New York: Oxford University Press, 2011.
Bragdon, Claude. *More Lives than One.* New York: A. A. Knopf, 1938.
Clune, Henry W. *The Rochester I Know.* Garden City: Doubleday and Company, 1972.
King, Warren. *America's First Boom Town.* Rochester: Rochester History Alive Publications, 2008.
Klos, Lloyd E. *A Resident's Recollections, vol. 1 – 7.* Interlaken, NY: Empire State Books, 1990.
Leavy, Michael and Leavy, Glen. *Images of America: Rochester's Dutchtown.* Charleston, SC: Arcadia Publishing, 2004.
McKelvey, Blake. *Rochester: The Water-Power City, 1812-1854.* Cambridge, MA: Harvard University Press, 1945.
McKelvey, Blake. *Rochester: The Flower City, 1855-1890.* Cambridge, MA: Harvard University Press, 1949.
McKelvey, Blake. *Rochester: The Quest for Quality: 1890-1925.* Cambridge, MA: Harvard University Windsor Publications, 1956.
McKelvey, Blake. *Rochester: An Emerging Metropolis: 1925-1961.* Rochester, NY: Christopher Press, 1961.
McKelvey, Blake. *Panoramic History of Rochester & Monroe County, New York.* Woodland Hills: Windsor Publications, 1979.
McKelvey, Blake. *Rochester, a Brief History.* New York: Edward Mellen Press, 1984.
Merrill, Arch. *Rochester Sketchbook.* New York: A. Merrill Publisher, 1946.
O'Keefe, Rose. *Images of America: Southeast Rochester.* Charleston, SC: Arcadia Publishing, 2006.
Paley, Albert. *Albert Paley: Threshold, Klein Steel.* New York: Rizzoli International Publications, 2008.
Pitoniak, Scott. *Baseball in Rochester.* Charleston: Arcadia Publishing, 2003.
Rochester Public Library: 100 years of service, 1911-2011. Rochester, NY: Rochester Public Library, 2011.
Rosenberg – Naparsteck, Ruth. *Remembering Rochester.* Nashville: Trade Paper Press, 2010.
Schilling, Donovan A. *Rochester Labor & Leisure.* Charleston: Arcadia Press, 2002.
Urbanic, Kathleen. *Shoulder to Shoulder: Polish Americans in Rochester, New York, 1890-1990.* Rochester, NY: K. Urbanic, 1991.

Newspapers and Journals

Democrat and Chronicle [Rochester, NY]
Leslie's Illustrated Weekly
Rochester Herald [Rochester, NY]
Rochester History [Office of the City Historian; Rochester, NY]
Times-Union [Rochester, NY]

Acknowledgments

We would first like to thank our editor Heather Martino for her wonderful work and Fonthill Media for presenting us with the opportunity to write this book.

We would like to express gratitude to the following institutions and individuals for their incomparable assistance with, and generous contributions to, this book: Albert R. Stone Negative Collection of the Rochester Museum and Science Center, Blue Cross Arena, Café 1872, City Hall Photo Lab, City of Rochester, Cunningham Estate, DePaul Properties, Department of Geology of the University of Rochester, Eastman Theatre, Genesee Brewing Company, George Eastman House, GEVA, Greater Rochester International Airport, Harris Communications, the Kate Gleason Digitizing Department of the Central Library of Rochester, Klein Steel, Landmark Society of Western New York, Library of Congress, Local History and Genealogy Division of the Central Library of Rochester, Mount Vernon Ladies Association, National Museum of American History, Neoscape, Office of the City Historian, Rochester Municipal Archives, Rochester Public Library, Rochester Red Wings Baseball, Savoia Pastry Shoppe, Smithsonian Institute, Susan B. Anthony House and Museum, Town of Brighton, Tipping Point Media, University of Rochester, Wegmans, Xerox.

Gavin Ashworth, Michelle Austin-Stritzel, Daniel Beaumont, Gene Bour, Kurt Brownell, Corinne Clar, Paul Constantine, Fran Cosentino, Bonnie Evans, Michelle R. Finn, James Fitta, Fred Heier, Cynthia Howk, Deborah Hughes, David Hunt, Jeannine Klee, Lea Kemp, Tom Kohn, Mary Jo Lanphear, Michael Leavy, George Lodder, Fred Lindenhovius, Jeff Ludwig, Anisia Mandzy, Mike May, Richard Margolis, Joan O'Byrne, Jane Parker, Jesse Peers, Laura Ribas, Michele Rowe, Elizabeth Sikorski, Ira Srole, Karen Ver Steeg, Dick Waterman, Pat Wayne, and Gloria Weyerts.

We are particularly indebted to the Office of the City Historian and wish to acknowledge the fine work of its past office holders. We would especially like to thank our current City Historian, Christine L. Ridarsky.

Finally, we would like to express our infinite gratitude to Michael R. Grenier and Ronald Stackman, for all the support, both moral and technical, they have provided in the making of this book.